SNOWBOARDING IN SOUTHERN VERMONT

SNOWBOARDING IN
SOUTHERN VERMONT

FROM BURTON TO THE U.S. OPEN

BRIAN L. KNIGHT

THE
History
PRESS

Published by The History Press
Charleston, SC
www.historypress.com

Copyright © 2018 by Brian L. Knight
All rights reserved

Cover images courtesy of the Burton Corporation.

First published 2018

Manufactured in the United States

ISBN 9781467139250

Library of Congress Control Number: 2018948042

In memory of my loving mother, Jean Scott Knight (1938–2018).
Thanks for bringing me to Vermont.

I been gamblin' hereabouts for ten good solid years,
If I told you all that went down it would burn off both of your ears.
—*Jerry Garcia*

CONTENTS

ACKNOWLEDGEMENTS

This book was a concept in 2015, with a rough skeleton put on paper. In June 2017, I went forward with the book and into overdrive. I thank all the people who responded to my rapid onslaught of queries and requests: Laurie Asperas, Peter Bauer, John Blackmer, Dave Boettger, Neville Burt, Tricia Byrnes, Skye Chalmers, Mike Chantry, Hobie Chittenden, Pete Christy, Jack Coghlan, John Conway, Chris Copley, Todd Davidson, Gilbert Debus, John DeNeufville, Mike Devito, Jason Dreweck, Jeremy Finaldi, Ryan Foley, Jason Ford, Myra Foster, Alexie Garick, Jason Goldsmith, Trevor Graves, Kimet Hand, Keith Hannum, Mike Hayes, Steve Hayes, Dennis Healy, Chuck Heingartner, Keith "K.J." Heingartner, Mark Heingartner, Randy Hoose, Paul Johnston, Scott Johnston, Todd "TK" Kohlman, Karen Knight, Neil Korn, Vince LaVecchia, Scott Lenhardt, Zander Livingston, Cindy Logan, Jesse Loomis, Myles Mahoney, Emmett Manning, Ian Martin, Pete McCostis, John McGrath, Kurt Meyer, Seth Miller, Matt Mitchell, Brew Moscarello, Seth Neary, Cater Olcott, Scott Palmer, Carol Plante, Ross Powers, Ian Price, Gillian Rathbun, Scott Richmond, Beth Trombly Renola, Shem Roose, Dave Schmidt, Hubert Schriebl, James Schriebl, Betsy Shaw, Kris Swierz, Beau Thebault, John "J.T." Thouborron, Rich Titus, David Van Houten, CB Vaughn, Alvah Wendell, Russell Winfield, the Woodruff family, Mimi Wright and Jon Yousko. Thanks to my family who have supported throughout the trials of tribulations of life. Thanks, Corinne, for the help. I am eternally grateful to Lindsay and Archer, whose laughter, curiosity and joy shine a light and a fresh perspective on the world that surrounds.

INTRODUCTION

During the summer of 1991, while a student at the University of Vermont, I worked for my father's company, Tubbs Snowshoes and Mansfield Canoes. Every year, my father went to the Snowsports Industries America (SIA) convention in Reno, Nevada. My duty was to deliver six canoes to and from Reno and occasionally man the convention hall booth.

The convention center was divided into two large rooms. One wing was reserved for the ski industry, while the second room was for everything else—hiking, canoeing, snowshoeing, backpacks, hiking boots, snowboards and snowshoes. A walk through the ski building was akin to the hallways of corporate America. There were large displays covering expansive amounts of square footage. The people walking around wore suits and ties and placed their orders with leather briefcases in hand. The room was solemn and stale. This was an accurate reflection of the industry at the time. Large corporations had taken over the mountains. The mountains themselves had turned into groomed-out retail zones. The age of liability had frozen the ski industry in its tracks.

A walk through the second wing told a different story. I was overwhelmed with a buzz of activity. Rock music blared from all corners of the room. It felt more like Bourbon Street or Shakedown Street rather than an industry trade show. Skateboarders performed tricks on mini ramps, kegs were dispersed throughout the room and occasional plumes of smoke rose through the vast hall. One company even hired the local "pros" to attract people into its booth. The difference between the two rooms was striking. I

was witnessing the changing of the guard. In the middle of the chaos were the snowboards companies, especially Burton. There were endless lines for taking orders and talking to the reps. Meanwhile, back in ski room, a moribund atmosphere prevailed.

While this description portrays the snowboard industry as a bunch of nonconformist rabble-rousers, that may be only part of the story. The early days of the snowboarding industry does have a fair share of debauchery in its lore. Looking beyond the party spirit, it is naïve to deny snowboarding's influence on the winter sports industry. In 1980, people were skiing on 195-centimeter stiff boards. If there was a terrain feature that remotely suggested getting air, the ski patrol erected enough bamboo poles to prevent any chance of liftoff. As the United States became more litigious, mountain executives perceived getting air as a potential lawsuit.

Thanks to snowboarding, ski areas cut glades through the woods, built terrain parks and hosted big air competitions, and leaving the ground is now the norm. Snowboarding became a valuable outlet for a multitude of outdoor enthusiasts as it provided a fresh and exciting perspective. Today, snowboarding has provided the ski industry with vitality. Everything from shaped skis to legal glades and terrain parks point to the snowboarding industry. In turn, snowboarding owes so much to skiing—P-Tex, metal edges and, most obviously, a mountain infrastructure with lifts, snowmaking, grooming and staff. The two sports had a symbiotic, albeit sometimes contentious, relationship.

I was passively thinking about writing this book for quite some time, and I was looking for appropriate bookends to this story. With the origins of snowboarding in hot debate, I knew that avoiding a general history and focusing on the local contributions to the sport was an appropriate beginning. As for the end, there was more of a challenge. Was it the exodus of Burton to Burlington in 1992? Was it the eventual transition of Burton's manufacturing operations to Europe? Was it the rise of Mount Snow's Carinthia and the eventual demise of Stratton's snowboarding epicenter role? Or was it Burton's transfer of the U.S. Open from Stratton to Vail? Was it the elimination of alpine racing from snowboard events? Was it the move of the half-pipe from the main mountain to Sun Bowl? Was it the fact that the Hayes brothers' party had a guest list?

This is not a history of snowboarding. It does not explore the early roots of the sport. It also is primarily a southern Vermont story. While Tom Sims, Mike Olson, Chuck Barfoot and Dimitrije Milovich deserve full recognition for their contributions, they are not here. This is not the story

of northern Vermont, and it does not venture far beyond Manchester and the Mountains. There are cursory tales involving Bromley and Magic Mountain, but there are more stories to be had. As for Killington, Okemo and Mount Snow, their contributions will be told another day. Early pathfinders such as Eric Webster and Chris Karol made an impact on the slopes of Stratton, but their important contributions may be slim but not unappreciated or overlooked. Many of the riders who made the U.S. Open so memorable—Craig Kelly, Jeff Brushie and Terje Haakonsen, to name a few—do not get the full coverage they deserve. This seems like sacrilege, for they are essential components to the growth of this sport in Vermont, but lines needed to be drawn. Similarly, the recent past does not receive the coverage it deserves—topics ranging from the Ross Powers Foundation to the Frendly Gathering are not found in these pages. While the progression of the sport is an essential part of the snowboarding story, there is no timeline tracing the J-Tear Air to the backside quadruple Cork 1800. Nor will you find a run-by-run summary of every U.S. Open. What you will find is a cadre of snowboarders, bound by a common interest and a powerful sense of camaraderie, athleticism and excitement. Everyone's story is different, as they follow their own paths. While their journey brings them far and wide, they found themselves in southwest Vermont, sharing a common bond.

TRIAL AND ERROR

JAKE BURTON CARPENTER NURTURES A FLEDGLING SPORT

MOONLIGHT IN VERMONT—OR STARVE

In March 2012, the annual Burton U.S. Open Snowboarding Championships at Stratton Mountain had a retro vibe to the weeklong event. In celebrating the thirtieth anniversary of Burton's first snowboarding championships, the competitor bibs resembled the 1982 bibs, the official poster featured an iconic image of the 1987 Burton team (see the cover) and Burton put on a retrospective exhibit. On Friday night, the Open featured the inaugural "Washed Up Cup," involving former U.S. Open competitors. It wasn't all a blast from the past, as the Saturday night entertainment featured Method Man (of Wu-Tang Clan) and Redman (of Def Squad). While a celebration of thirty years of snowboarding competition in Vermont, the nostalgia also—unknowingly to the attendees—served as a swan song. Three months following the 2012 Open, Burton announced the relocation of the time-honored event from Stratton to Vail, Colorado. The news shocked both the southwestern Vermont population and the snowboard community, leaving a cavalcade of emotional responses. While the pros and cons of the migration are still debated, the move serves as an opportunity to honor the decades-long liaison between snowboarding and southern Vermont. The 2012 exodus was an appropriate bookend in relation with the other bookend of forty-four years earlier, when Jake Burton Carpenter received a Snurfer as a Christmas present while vacationing in Vermont. Invented in 1965, the Snurfer was a single piece of wood with staples for traction

and a rope. While simple in design, the gift ignited a lifelong passion for Carpenter. In those early years, the Snurfer and snowboarding seemed to be in his back pocket, an idea floating around in his mind, waiting for the right opportunity to bust out.

With his foundation in alpine skiing, Carpenter attended the University of Colorado with aspirations of racing. Coupled with waning interest, a series of collarbone fractures altered his skiing career. He returned to the East Coast to attend New York University and study economics. During this time, he worked for a small investment banking company. He interviewed entrepreneurs, prepared research reports and presented them to potential buyers. Carpenter's friend Myles Mahoney recalled that he inspected small operations, "learning a lot about manufacturing," which Mahoney knew "was key. How else would have he learned things?"[1] Through this work, Carpenter talked to "successful entrepreneurs and realized that it's not impossible to get a business going," recalled Jake. "The people I was dealing with didn't bowl me over with their capabilities. They seemed like normal people, and I was like, 'Shit, I could've done that.'"[2]

After graduating from NYU in 1977, Carpenter stayed in the financial world, but he eventually experienced burnout. After hitting the "eject button," he relocated to southern Vermont and started Burton Boards. A relative, Mimi Wright, suggested that Carpenter move to Londonderry, a town close to where he first tried Snurfing nine years earlier. Carpenter learned woodworking, opened a small shop in Londonderry and recruited his first three employees—including relatives Mark and Mimi Wright. Locals expressed doubt about the new operation, located right across from a deer-weighing station. Carpenter joked that "they thought that we were a front for a drug operation—they thought this snowboard was no way."[3] During that first winter, he held a competition among his employees—$100 for the best logo. Mimi Wright won the challenge with her iconic snow-capped mountain. Carpenter recalled that the four of them "tooled up and made 50 boards a day. That was our goal, and we *&^%ing did it."[4] There was a lot of trial and error in the manufacturing process. The wood planks snagged in the router, "catapulting them through the barn wall 'like something out of Austin Powers.'"[5] Carpenter admitted to feeling like "a fish out of water," and the early mistakes "could easily have been the end of me."[6] He recalled, "It seemed like starting a business wasn't that difficult....I thought I could just get it going, but it wasn't a service business. It was a manufacturing business, and I didn't even have a product."[7]

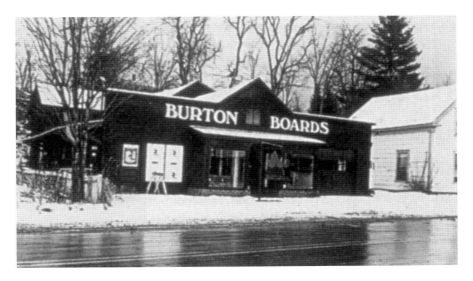

Burton Snowboards' first factory, located in Londonderry, Vermont. *Burton Corporation.*

Carpenter was "naive but well-intentioned," as he "figured he could come up with a product and have it on the market in a few weeks."[8] He made hundreds of maple wood prototypes, but they were rejected due to strength of the board or costliness to construct. In 1979, he produced the first production model, the BBI, which "pointed the way (if not the shape) of things to come, with Regular and Goofy models, light weight, and tool free binding adjustment, plus both top and bottom graphics—new ideas for a sport in its infancy."[9]

They only sold 300 to 350 boards. Carpenter laid off his small staff, including the designer of the logo, Mimi Wright. Carpenter returned to Long Island to tend bar and teach tennis. The retreat to Long Island was the result of having neither stock nor a customer base. "He had one or two models," explained Myles Mahoney. "There was not enough to go through the summer. It was in its infancy so he needed to work and also, it was where his roots were, so he wanted to hang out on the beach"[10] With "100 grand in the hole," Carpenter had a moment of catharsis.[11] "When I hit rock bottom…I realized that it was really important to me that the sport succeed. I stopped thinking of it as my company and started to think [of] the sport…. When I actually let go and started taking that attitude, that's when things really started to take off."[12]

All you need is a hill, some snow and a

BURTON BOARD ™

We've been making Snow Surfers™ for ourselves for over ten years. Now we can offer you the finest product made in this rapidly growing winter sport. Some of the characteristics of the Burton Board™ which set it apart from the competition are listed below:

- Twin fin (rudder) design capable of performing in a wide variety of snow conditions. (extensively tested in New England, Utah California and Austria).

- Safe, adjustable, front and rear rubber step-in bindings including run-away strap.

- Affordable price providing the best dollar value in the field - - - high performance durable construction.

- Lightweight and portable design is ideal for "backyard" use as well as groomed slopes.

Let us tell you more about this exciting new winter recreation, and the Burton Board™ in particular.

Burton Board and Snow Surfer are registered trademarks of The Burton Corporation

BURTON BOARDS™
P.O. Box 365
Stratton Mtn, Vermont 05155

Name _____
Organization _____
Address _____

Phone _____

Left: The first Burton Snowboards advertisement. *Burton Corporation.*

Below: Early Burton Snowboards team rider and downhill champion Doug Bouton. *Burton Corporation.*

Ian Martin of Londonderry joined a revamped factory crew of Jake and Doug Bouton. The three had a small operation with Ian sanding the skegs and Doug and Jake working on the shaping, graphics and hardware. According to Martin, Doug Bouton is unheralded in the early history of snowboarding, and his contributions have been lost. Martin joked that Bouton "was way better than Jake at riding, and Jake was way better than me."[13] Bouton spent a lot of time in the Londonderry barn and then went on to win many early races. Bouton knew Andy and Jack Coghlan, future Carpenter employees. In a barn behind his house, Bouton made skateboards, and the Coghlans "had heard through the grapevine that Doug had gone on to become Jake's main pro at the time."[14] Mark Heingartner, future Burton rider, recalled that Bouton "was *the man* early on. He was the best rider in the country. He had a super natural style, kind of like a skateboard-style guy. He was built like Tony Hawk, tall and lean and lanky. He got down the hill, for a couple of years there, quicker and faster and better than anyone else."[15]

Within a year, Carpenter's prospects were better, and after selling his 700th board, there "was just a hint of momentum. It was encouraging. Financially, we were continuing to eat it…but emotionally I started to feel more positive."[16] The 700th board was more of a morale victory than a financial one, as the boards were surplus from the previous year. Carpenter recalled, "I was just taking them, wiping the dust off and getting them out the door."[17] Ted Janeway, a childhood friend, recalled that "Jake was fooling around with this when all of us were getting real jobs.…He had a drive to succeed and a love of the sport, and it just caught on."[18]

On New Year's Eve 1981, Carpenter went to the Mill Tavern in Londonderry. There he met his future wife, Donna, a Columbia University student. He introduced himself and said "he made snowboards in his barn.…[He] didn't think it was going to last five minutes."[19] Donna shared a worldwide sentiment, as "nobody had ever heard of snowboarding." She remembered that her reaction was "Whatever. I'm way too sophisticated." That night, Jake showed Donna the product of his mysterious livelihood. "I said, 'Let's try it.' And it was just a wooden board with a rope and a water ski binding in the front and a strap in the back, and we wore high top sneakers. And I never thought I'd leave New York for that, but I did."[20] After their fateful meeting, Carpenter broke off a date with another girl, and the two commenced a thirty-year journey together.

Above: Jake Burton Carpenter spent hours building and testing prototypes. *Burton Corporation*.

Left: Jake and Donna Carpenter first met on New Year's Eve in Londonderry. *Burton Corporation*.

THE CHICKEN DANCE

Prior to the advent of the ski industry in Vermont, Stratton was a sleepy mountain town. It was known for Daniel Webster speaking in support of William Henry Harrison in 1840, the home of back-to-the-earth pioneers Helen and Scott Nearing and the home of author Pearl S. Buck. In 1961, the area experienced a profound change when Frank Snyder, Herbert "Tink" Smith and Senator Edward Janeway opened a new ski mountain. Stratton hired architect Alexander McIlvaine to design a base lodge, and in Montpelier, Senator Edward Janeway pushed through an appropriation for construction of the access road. Two days before Christmas 1962, Stratton Mountain officially opened with three double chair lifts and eleven trails. The arrival of a ski area served as an economic boost for a small mountain community that experienced growing pains in twentieth-century Vermont. With the ski industry came "tourism, the capital, and the residents needed to revive the town, economically."[21]

While Carpenter was trying to make ends meet, the Birkenhaus was the gateway to Stratton's alpine culture. Austrian Emo Henrich, director of the groundbreaking Stratton ski school, operated the Birkenhaus Inn with his wife, Annedore. A native of Innsbruck, Austria, Henrich was more than just an innkeeper and skier. He was a painter, engineer, climber, singer and racer. Arriving in 1961, Henrich molded the Stratton identity for the next twenty-six years. He touched the lives of so many Stratton visitors through his hospitality, enthusiasm for skiing and the quintessential Stratton après ski activity, the dancing and singing of renowned Austrian ski instructors who moonlighted by playing Tyrolean folk music as the Stratton Mountain Boys.

Otto Egger and Emo Henrich formed the Stratton Mountain Boys in 1965. Egger recalled that Henrich "wanted people who could teach the ski technique of Austria but also entertain and spread the culture of Austria."[22] The Stratton experience of the 1960s centered on an event known as Ski Week. Stratton guests "skied and socialized together all week under the tutelage of instructors, who, clad in red sweaters emblazoned with a big black eagle, demonstrated their skills en masse down Suntanner, culminating with Hermann Goellner's signature layout flip."[23] The Stratton Mountain Boys were an essential component to Ski Week, as they "taught skiing all day and appeared in their trademark red V-neck sweaters in the Base Lodge each afternoon for après ski Tea Dancing."[24] The Stratton Mountain Boys held weekly Tyrolean evenings with skier/musicians "clad in authentic Tyrolean lederhosen and introduced thousands of Stratton

guests to the Chicken Dance, the Woodchoppers Song and Jealous Lovers Dance. The Stratton Mountain Boys' unique ability was to share their Austrian culture and music, but more importantly to provide a venue for all ages to have fun, dance and enjoy being together, making memories in the mountains of Vermont."[25]

The Stratton of 1977 resembled a Tyrolean village. Herbie and Gretel Schachinger operated the nearby Liftline Lodge, and Walter and Hannah Heigl managed the Hotel Tyrol.[26] It was a remarkably different vibe in those early days of Stratton skiing. In addition to the Stratton Mountain Boys, "memories of these happy days include tea dancing in the Bear's Den…fabulous picnics in the spring orchestrated by the Birkenhaus at the top of the Grizzly Bear complete with a raw bar, champagne and wonderful delights on the grill."[27] Brought together by winter snow, the lure of descending a slope and social camaraderie, the early Stratton folks' spirit was not much different than the ethos of the snowboarder who arrived twenty years later.

DREAMED I SAW THE BOMBERS

As part of its Fourth Annual Woodstock Winter Carnival, the Suicide Six Ski Area hosted the 1982 National Snow Surfing Championships. Reflecting the obscurity of the sport at the time, the newswire announced, "No, we are not making this up! If you like snow and have a taste for the unusual, consider the National Snow Surfing Championships."[28] About 150 participants registered for the slalom, giant slalom and freestyle events. The event's organizer, Paul Graves, was the owner of Snowboard East, one of first exclusive snowboard retail shops in North America.

The news focused on the freak nature of the sport through the play on words in the headline "Snow Surfing Tourney Is Snow Joke," and during a *Today Show* spot, Bryant Gumbel and Willard Scott "were giggling to themselves as they delivered the news to millions from their anchor desk deep in New York City."[29] Although he broke his thumb as he crashed into the finish line hay bales, Californian Tom Sims won the downhill; Burton rider Doug Bouton won the slalom and claimed overall honors. Bouton hurtled "63 mph down a steep hill in sneakers at a resort appropriately called Suicide Six."[30]

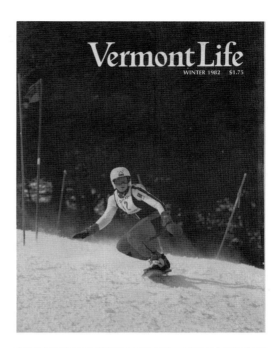

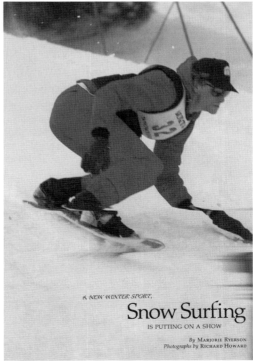

Top: The 1982 National Snow Surfing Championships at Suicide Six Ski Area in Woodstock, Vermont. Vermont Life.

Bottom: The 1982 champion, Doug Bouton. *Richard Howard.*

The following year, the Snow Valley Ski Resort near Manchester, Vermont, hosted the championships. Snow Valley was an ideal location, as it "was super liberal. They didn't have like a lot of the concerns that the big mountains were concerned about." Mark Heingartner remembered, "They weren't stressing about liability. They pretty much were like 'Yeah, you want to buy a lift ticket, go for it.' They didn't care if you carried the boards up, if you had a leash, if you were giving lessons—they were 'buy a ticket and go.'"[31] Carpenter recalled that Snow Valley "was so mellow you could bring your dog on the chairlift."[32]

By the second year of competition, Burton Team riders Steven O'Hara, Andrew Coghlan and Mark Heingartner held world records. At the 1982 event, the organizers took a dining room table, turned it upside down and buried the top in the snow. The result was four legs sticking out of the ground, which the riders used to propel themselves out of the gate. By 1984, a crude starting gate was built out of two-by-fours. "It was really fun. It was so small," Jack Coghlan reminisced, "even though you're competing against these guys, there was a camaraderie because we were all snowboarding at the time and hardly anyone did it."[33]

The snow during the 1984 event was "solid corn snow," making it hard for many to descend down the mountain, plus there was one knoll that claimed many racers. "The top ten guys, maybe fifteen, would all make it down without falling, and then the rest of us would take one good fall," recalled Jack Coghlan.[34] There were hard tumbles, but as long as the racers crossed the finish line, their score counted. Coghlan added, "If you made it down clean, you were pretty much right in there."[35]

In what may have been the first U.S. Open party, Snow Valley allowed the competitors to camp out in the base lodge. According to Mark Heingartner, "There was a crew of snowboarders from Michigan, and Tom Sims came from California and his crew. There was a Rhode Island contingency, a Massachusetts contingency. They all needed a place to crash."[36] Jack Coghlan remembered that "it was just a massive party that night.…People built skate ramps, and they had kegs." In an image that would manifest itself a few years later in places like the Hayes brothers' basement or the Crack Den, "a lot of people pulled out their sleeping bags and stayed right in the lodge there."[37]

During the competition, everyone who worked at Burton "was involved in one shape or another," according to early employee Gilbert Debus. A student at Burr & Burton, he went to work for Burton in 1982. Debus worked for Burton for about six months, after school and on Saturdays, making eight

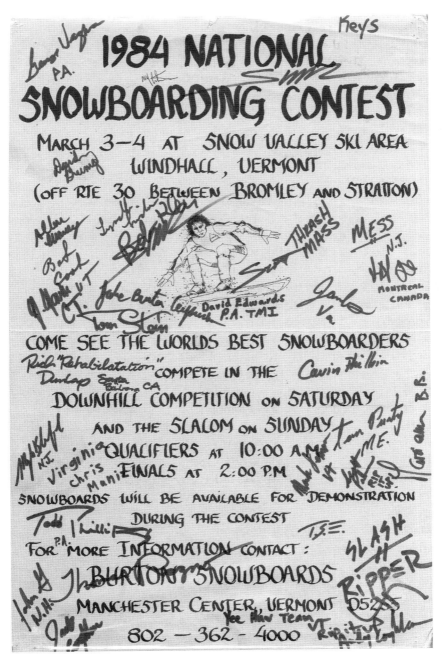

By 1984, the snowboarding championships had migrated to the Manchester and the Mountains area. *Burton Corporation.*

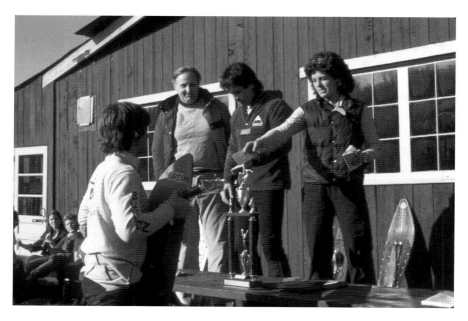

The informal awards ceremonies were held on the deck of the Snow Valley Ski Lodge. *Burton Corporation.*

Burton team rider Chris Karol. *Hubert Schriebl.*

or nine dollars an hour. During the event, he volunteered as a board tech, replacing skegs after each run. Jake and Andy Coghlan "had front line privileges," and they spent the day "trying different combinations" of wax and "trying to get it right."[38] Jack Coghlan remembered that "people at that time were sanding down the fins so that they get valuable time and not dig in so much." By 1984, "fins were taken off, and we were screwing in actual steel edges to the bases of the board—it was it was still pretty crude."[39] The equipment was certainly primitive, as the racers wore high top sneakers and luggage straps for bindings.

In the documentary *Powder and Rails*, Carpenter recalled the event as a "daredevil type scene. Because in the beginning, it was like downhill….It was sort of where we were at…charging down the hill."[40] Donna Carpenter remembered a female rider who "cried at the top for like twenty minutes until we talked her into going. So, it was very intimidating."[41] During these first three years of New England competition, the focus was on alpine racing events. Brothers Andy and Jack Coghlan "were hardcore ski racers," Jack Coghlan remembered. "Andy, right away busted out a downhill suit from ski racing, and the other guys from the Sims Team were in their regular clothes."[42] The West Coast skateboard and surf culture had yet to fully permeate the sport, and the alpine skiing influence still dominated tournaments.

NIGHT RANGERS

With snowboards relegated to backyards, golf courses and the woods, there was an ever-present hunt for ideal snow coverage, length and incline. In their free time, the Londonderry crew took runs at a place referred to as "The Tit," a small hill with great incline off of Route 100 in South Londonderry. They also journeyed up to Stratton to "The Pit," located between the base lodge and the Sun Bowl. When Mark Heingartner entered the scene, he and Carpenter "did a lot of hiking at the mountains….After hours and in the early mornings, we would hike Bromley and Stratton."[43]

It was difficult to snowboard on a packed, groomed surface. Most opportunities involved clandestine evening missions. During the winter, Carpenter tended bar at the Birkenhaus, a local landmark known for its Tyrolean hospitality, wiener schnitzel and haircuts. Emo Henrich, the

Jake Carpenter testing a board near Stratton Mountain. *Burton Corporation.*

owner of the Birkenhaus, apparently "fully supported and mentored Jake's snowboard development," but he was never really aware that his lodge was being used "after hours as a spray room for the paint and stencils seen on the early boards."[44] Carpenter often tested the prototypes across the street. There are little vestiges of the scenario that remain today. The Birkenhaus is long gone, and there is a wall of condominiums on the other side of the access road. In the late 1970s and early 1980s, only an expansive gravel parking lot served as a barrier between the inn and the mountain.

They also hiked up the Lord's Prayer trail at Bromley. Ian Martin recalled that he, Doug Bouton and Carpenter walked up the trail to practice for races. They were "bombing down Lord's Prayer, and it seemed like a huge slope. It was scarier than heck on these small wooden boards." Later, the Bromley excursions improved, as "we got a little more sophisticated, we would go up to Bromley at the end of the day." Martin knew members of the ski patrol who allowed them to ride the lifts at the end of the day when the patrol conducted its final sweep.[45]

When the factory moved to Manchester, the crew often conducted their own research and development. Upon returning from trips, Jake went into the workshop and designed a new board "as he had his ideas of how it would

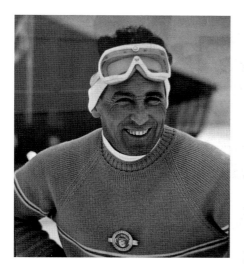

Emo Henrich, founder of the Stratton Mountain Ski School and responsible for molding Stratton Mountain's early Tyrolean identity. *Stratton Foundation.*

progress from the last one."[46] With new prototypes, the crew visited a hill directly across the street. A popular spot for fireworks observation and high school romantic trysts, the hill leading from Village View Road toward Carpenter's house and barn served as an excellent test site. The incline remains, but the open fields are long gone. They also parked at the bottom of Union Street near the Battenkill River and raced up to the Equinox Golf Course, which provided a great alternative, for it had "a lot of bunkers, and a lot of terrain. It wasn't straight downhill."[47]

At night, the crew piled into Andy Coghlan's Volare station wagon, with one serving as the designated driver who brought the rest up to the trailside condominiums, dropped them at the top and then waited at the bottom. John McGrath recalled, "You really learned how to snowboard in the middle of the night when it's darkest as can be and all of a sudden you're sucking up bumps that you don't know were there—it's pitch black dark…long before headlamps."[48] Poaching runs on Lord's Prayer and Plaza, they took turns with the driver duties. Jack Coghlan added, "The rest of us would just hammer down Bromley and then get chased away by the security guard at the base, but someone was waiting in the car to pick us up."[49] Mark Heingartner recalled, "I always had a way about not getting caught. I was never the last in line.…I don't usually look behind to get caught. We would just go straight to the parking lot and not wait around to get scolded."[50]

Donna Carpenter also played a key role in this "surreptitious snowboarding." Prior to their evening sojourns, Donna brought "shoe boxes of brownies" to the groomers "in exchange for a ride to the top."[51] Many others looked to the groomers for free rides to the top. At first, the poachers tried "to stay out of the path of the cat drivers so they wouldn't even see us," remembered Mark Heingartner. "But then some of those guys became friendly with the cat drivers."[52] Scott Palmer, prior to joining Burton, worked evenings at Bromley. A groomer friend gave Palmer and his co-workers

Jack Coghlan (*pictured*) and his brother Andy were early factory employees and team riders. *Hubert Schriebl.*

rides to the top. After they finished their shifts, they had "a couple of beers, get a ride up, take a few snowboard runs, go back to the bar, grill burgers and punch out."[53] The groomers also proved to be rather illuminating, as the riders tried "to time it so we have the groomer turn around," Palmer continued, "and then ride in front of them to use the headlights from the groomer. After you got a little way down, you were way out of his light."[54]

Even after snowboards were officially allowed on the mountains, Burton employees still sought mystery hills. When Route 7 was under construction, the factory crew often went up to the construction sites where there were steep cuts in the hillside. The lack of snow did not deter them, as they often found themselves snowboarding on rocks and grass in the construction sites.[55] "Everybody there, minus a handful of people, were into snowboarding. And we did it all the time," Scott Richmond recalled. "On a brightly moonlit night, we'd hike up Bromley and snowboard at one o'clock in the morning with a few drinks in us because, you know, what else are you going to do when you're in your twenties."[56]

BARN BOARDS

In the early 1980s, Carpenter moved operations to a farmhouse and barn in Manchester. One of the earliest employees was Bob Novak, who dated Andy and Jack Coghlan's sister. When Novak decided to return to Michigan, a job opportunity arrived for the Coghlan brothers. Jack Coghlan recalled that Bob approached Carpenter and said, "'Hey, I know these guys, Andy and Jack, that would be willing to take over,' and Jake was in such a pinch to find someone, he gave us a shot."[57] Having joined during the summer, the Coghlans' first experienced snowboarding when the snow fell. "When the winter rolled around after building the boards, we were really psyched to jump on them and start to learn how to snowboard," Coghlan added, "and quickly picked it up and loved it....It was a major passion of ours from then on."[58]

The boards arrived already cut and formed, and the workers were responsible for coating them with polyurethane and applying the metal skegs. It is uncertain whether OSHA made its presence known in this two-story barn, but the workers did wear respirators when they dipped the boards in polyurethane. This last stage seemed to be less desirable. The

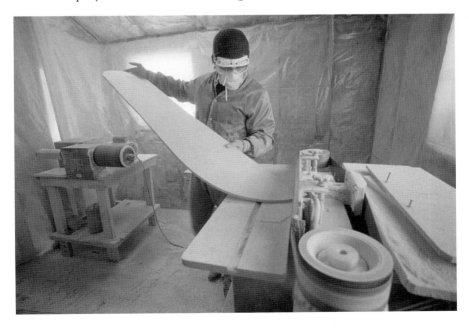

Jake Carpenter working in the Manchester Factory. *Richard Howard.*

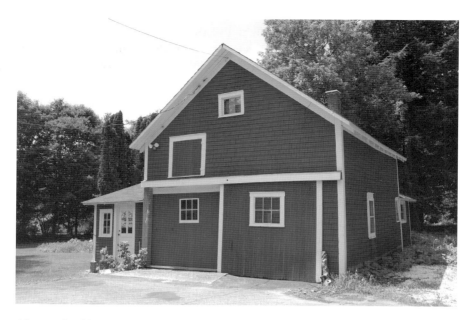

After moving his operations to Manchester, Carpenter set up shop in the barn behind his house. *Brian Knight.*

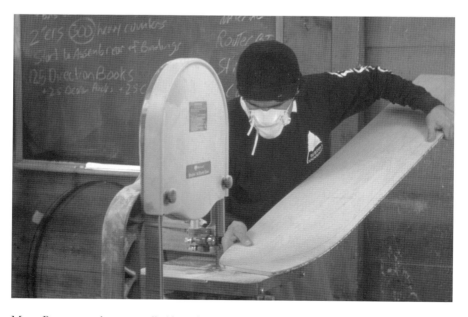

Many Burton employees recalled boards catapulting from the shaping machines and embedding themselves in factory walls. *Burton Corporation.*

workers used a long pole that attached to the nose and tail of the board, and they dipped the boards in a large vat. Then they hung the boards on hooks like slabs of beef in a butcher shop. Without the respirators, fifteen minutes in the room was like sniffing glue. The dippers wore "big cloth suits and a big air mask," entered the room and were sealed in."[59] They spent two to three hours in the small room, processing hundreds of boards. Like paratroopers in World War II receiving extra pay to jump out of planes, the dippers got hazard pay in the form of fifteen dollars. The sealed-in workers were attached to an air compressor, which was a life support system for the dippers. In many instances, the non-dippers snuck a joint in the compressor's intake valve, and "this thing would suck down a joint in like twenty seconds."[60] Carpenter often gave the dippers a mandatory timeout. Often they had "two hours left of your shift, and he didn't want you to screw up anything or cutting your thumb off with a band saw because you were so stoned off the urethane," recalled Jack Coghlan, "He would say 'Go take a nap on my lawn for two hours and call it a day.'"[61] Palmer added with a snicker, "We blame all our mental shortcomings on Jake."[62]

Carpenter had other incentive programs, such as "if you were on time you'd get eight fifty an hour but if you were late you would only get eight

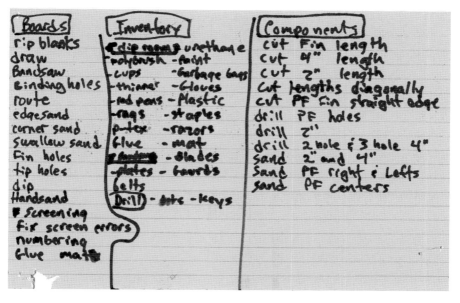

Jake Carpenter held on to many of his early production notes. *Burton Corporation.*

bucks for the day," recalled Scott Palmer. There was a hierarchy of work in the shop, with grinding fins being the low job on the totem pole. Palmer continued, "If you were on the shit list you had to either cut fins or sand fins, which were the worst jobs in the whole manufacturing process."[63] Jack Coghlan felt that Andy, who managed in Jake's absence, also ran a tight ship, and "if you were on Andy's bad side or if you were late, you were stuck sanding fins."[64]

When the boards were complete, they were packed up and shipped off. In these days, most of their business was mail-order based. The ubiquitous catalogue permeated through the snow sport world, and orders filtered in. Eventually, Carpenter had distributors all around the world, and larger orders were shipped out. One time, Jake went on one of his trips, and he left Andy and Jack with a large order of six hundred boards. Three hundred of the boards were designated for his Japanese distributor, which "was how Jay kept his whole business going…this Japanese guy who could pre-pay everything"[65] The two went through the first three hundred with no problems, but when they started the next batch, they ran out of red ink for the distinctive red boards. Andy made an executive decision and went with yellow. When Jake returned from his trip, he "f*&§ing loses it and blows a gasket on us."[66] He yelled, "'What the hell were you thinking?' The two responded, 'Hey dude, we had to get this done.'" Even potentially compounding the situation further, the distributor was with Jake at the time. The distributor's response was "Fantastic!" as he was "stoked he had his own colorway!" Jake left the room, leaving Andy and Jack fearing a repercussion, and when Carpenter returned, he said, "Oh my god. Thank you, guys. He just tripled his order and he wants them all in yellow."[67]

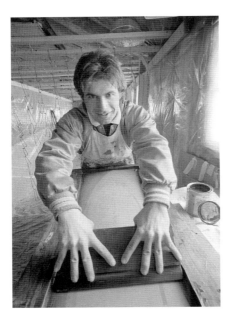

As the company grew, Jake spent less time building boards and more time promoting the sport. *Richard Howard.*

While demanding timeliness and always concerned about product control, Carpenter was not a slave

driver. Occasionally, Carpenter, a rabid New York Giants fan, called for timeouts so that the crew could play a game of four-on-four football. These football games continue today as the main event at Burton's annual Fall Bash. As a form of corporate bonding, they also played once a week at the rec park. The weekly games were full-fledged events. "It was probably like six on six. I remember it being a lot of guys. We had a line, it was rushing and everything. That was the competitiveness of Jake. He loved the competition and encouraged those kinds of things."[68]

2

ACCEPTANCE

SNOWBOARDING ARRIVES AT THE SKI AREAS

PJ

Getting the ski areas to allow snowboarding was an ever-present goal for Carpenter. "When we started to get a little bit more daring and looking for a little cameo," remembered Mark Heingartner, "sometimes we'd hike up in the morning before the lifts opened and we would do first tracks. When everything was all corduroy and groomed and we'd come down North American right onto Suntanner. Basically, when the ski patrols were on their way up. We were coming down. That was our introduction—'Here we are, and yeah, we can actually turn and stop these things.'"[1] While certainly a fun approach to public relations, this was not going to achieve the goal of mass acceptance. Carpenter sought legitimate recognition, and poaching was the not the route. He had to work within the system. He recruited Mark Heingartner, who spent days making calls to prospective mountains. Heingartner recalled that after talking on the phone, they went to the mountains, "doing demos for them, introducing the sport to the resorts."[2]

During the winter of 1983, Carpenter demonstrated snowboarding to Stratton employees. Much of the initial success can be attributed to Stratton's VP of operations, Paul "PJ" Johnston. Carpenter, Heingartner, Coghlan and few others took ski patrol members on a demonstration tour. "They were all on skis," recollected Mark Heingartner. "We were on our boards showing them how boards work—how we could go from top to bottom, how we get off lifts and we could actually hold an edge and stop."[3]

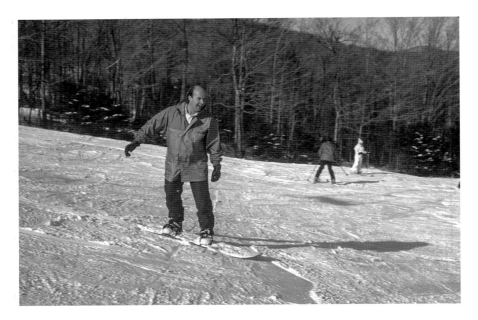

Stratton Mountain director of operations Paul "PJ" Johnston. *Hubert Schriebl.*

After the demo tour, Johnston wanted his staff to try the sport as well. "They were doing it for business. They were doing it to evolve and to grow and sell more lift tickets," remembered Heingartner, "So he wanted to see that not just the team riders and the core guys could do it but it could be a developing sport."[4] The introduction was a success, which Carpenter attributed to the weather conditions. The sun was shining and the snow was soft, so the testers had ideal beginner snowboard conditions. Carpenter added, "Had it been boilerplate, things could have taken a different turn."[5] After successful tests, Johnston took a leap faith and met with his board of directors. Johnston faced stiff opposition from the group, "but since none of them had good reason, he decided against them and made the executive decision to give snowboarding a trial period."[6]

With little support from the board room, Johnston took a calculated risk and granted Carpenter a snowboard probationary period. According to Carpenter, Johnston said, "I met with the board. Nobody wants you on the hill, but nobody had a good reason, so I'm going give you guys a shot."[7] Carpenter recognized Johnston for "being forward thinking, open minded and opening the trails for snowboarding and really for opening our hearts and minds to this new sport."[8] Soon thereafter, Stratton became the first

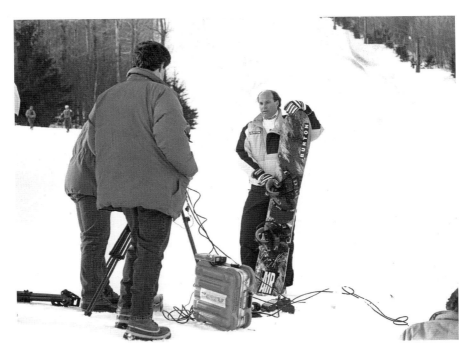

With Stratton Mountain opening its slopes to snowboards, Paul Johnston found himself in the media spotlight. *Hubert Schriebl.*

major resort to allow snowboarders on lifts. Stratton did not take the stance of reluctant acceptance, but at the same time, there were a slew of detractors. Paul Johnston recalled that "everyone came to my office to complain. The first month was hell. Everyone came [and said] 'These kids are dangerous. These kids are hoodlums.' I just said, 'No, you're wrong and we're going to keep going with this.'"[9]

The Stratton Ski Patrol had reservations about the new sport. In the beginning, they did not feel much of an impact as the critical mass of snowboarders was minimal and they were "not interacting with a group of snowboarders on the mountain....It was just a couple people learning stuff over on the Yodeler."[10] In time, the ski patrol had a larger situation to deal with. With the onslaught of beginners, they saw an increase in collisions as beginner snowboarders did "a lot of traversing and big turns....it is not the same style that you see usually with skiers. It threw a lot of people off."[11] The second noticeable change for ski patrol was the increase in upper body injuries—"wrists...forearms...dislocated

41

shoulders...collarbones...more back boards because when you catch your downhill edge, you come down on your head hard."[12] There was certainly an uneasy relationship between snowboarders and skiers in these early years: "It was more or less tolerated. We had ideas of this trail for snowboarders only and this trail for skiers only. That didn't really work....It just wasn't right. So, you just kind of kind of let them get along."[13]

Johnston was known for a great laugh, a wad of chewing tobacco in his mouth and general love for life. "I loved working with Paul. I really did. I thought he was so down to earth like 'come one, come all,'" recalled former snowboard instructor Neville Burt in 2017. "He was inclusive. He didn't take shit from anybody....I thought he was brilliant. He needs to take a lot of credit. Without him it may not have been completely different, but it has definitely been different."[14]

BLOODY SUNDAY

Many believe that ski resorts discouraged snowboarding due to insurance liability. Ironically, the court case that set the liability fears in motion occurred at Stratton in 1977. While skiing on a beginner slope, James Sunday crashed when he hit a patch of grass loosely exposed by snow. Sunday was paralyzed from the accident. In 1978, a jury "ultimately found Stratton to be 100% at fault for the accident and awarded Sunday $1.5 million in compensatory damages."[15] The jury made the award "on the grounds that Stratton had a duty to keep the bunny hill free from hazards."[16]

The Sunday case caused panic among ski areas. Due to the drastic increase in liability exposure, insurance premiums for many ski areas across the country doubled or tripled on the heels of the decision. As a result, "the price of lift tickets skyrocketed," at least four small Vermont ski areas shut down completely and "the two primary ski area insurers threatened to withdraw from Vermont during 1978, effectively putting in jeopardy one of the state's major industries."[17]

Paul Johnston recalled in 2017:

> *The lawyers ruined skiing for a while, and they drove a lot of kids away. We used to have a lot of jumping contests, gelande contests, bump contests....We could go skiing in the woods,* [and] *then Stratton vs.*

Sunday *happened. Everything went nuts after that. Everything had to be padded, everything had to be groomed and everything had to fenced. You have to put up slow down areas at the bottom of your lifts. It got so over regulated by insurance companies that they took all the fun out of skiing. They literally made it so it wasn't fun anymore, and kids stopped showing up. So, when we allowed snowboarding, we had a whole new approach for the kids to come in and get rid of their energy and enjoy.*[18]

OLD SCHOOL

The key to the initial success was Burton's development of a certification program. Realizing that he and his company had a gigantic opportunity, Carpenter strove to be error-free. The first instructor was Mark Heingartner. Under his direction, the fledgling program established a two-tier certification program. The instructors first certified neophyte snowboarders for the lower mountain, and then they graduated to the advanced upper mountain. Jason Goldsmith grew up riding on a homemade board in his backyard in Dummerston. Eventually claiming the now defunct Maple Valley as his home mountain, Goldsmith made the transition to Stratton, where he was certified by instructor J.G. Gerndt, who "would go down ahead of you and they want you to make a couple turns and then they want you to brake and they would want you to traverse. Depending on how you did, they would either give you lower mountain or give you upper mountain."[19] Mark Heingartner recalled that Burton "wanted no one to *&§% it up. We were pretty conservative. Looking back, it was kind of silly, it was almost to a point where you had to be as good as a team rider to get an upper mountain pass the first year or two."[20]

In speaking about Mark Heingartner, Paul Johnston recalled that Jake "couldn't have picked a better person." He continued,

First of all, [he was] a good-looking kid…great attitude about snowboarding. He could present himself well to adults who really hated snowboarding. Mark was really good, running and teaching all these kids. He also taught them manners at the beginning. If we are ever going to get this thing so we can go to the whole mountain, we've got to act the way skiers expect us to act until we can get our freedom.[21]

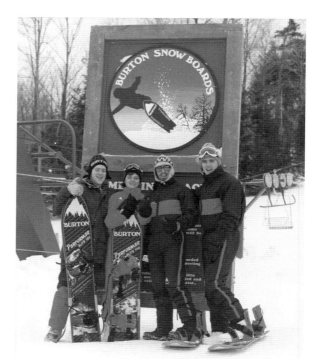

Right: In order to snowboard on the mountain, all riders required certification from an instructor. *Hubert Schriebl*.

Below: The certification program brought many riders from the backyard to the groomed slopes. *Woodruff family*.

The certification program provided a transition from backyards to the groomed trails, but it was no guarantee to a chairlift ride. "You had to hike up on the trail next to Tyrolean," Tricia Byrnes recounted, "And then we could ride down and then hike up and ride down. The first days I did it, it was so fun, even though all you're doing is eating shit the whole day."[22] After hiking and learning, the next step was riding the lift and getting off without falling, "which was a feat on those old lifts because they were so steep. If you ever wondered why the lifts always stopped in the 1980s," Byrnes recalled, "it was because it was like a black diamond to get off of it."[23] Beth Trombly Renola added, "That's my least favorite part of snowboarding still. I don't like it. You just don't know what the person next to you is going to do."[24] Matt Mitchell arrived in 1985 and hiked Tyrolean with Heingartner—"He just stood there [saying], 'You keep your knees bent, put your weight on the front foot and steer with your back foot.' That all he said...he watched us wreck all day."[25]

There was an uneasy relationship between the skiers and snowboarders. A rivalry developed between the two, and snowboarders attained reputations as punks. Skiers also blamed snowboarders for pushing snow off the mountain and colliding with skiers because of their heel side blind spots. Stratton even declared one of the upper mountain trails, Tamarack, off limits to snowboarders. The ski patrol and the snowboarders really butted heads, according to Dave Boettger, in "our secret backwoods society." Patrolman Dave Boettger joked, "We really hated the snowboarders. If we could have shot them in the woods and buried them in the snow and no one knew the difference, we would have." The skiers prized their woods trails, especially in the pre-glades era at Stratton. They felt the snowboarders ruined the narrow trails. When they got into the steep and narrow terrain, they could not make the "tight back and forth turns otherwise they would be going like a million miles an hour by their fourth turn and crash. So, they would turn their board sideways and slide down the steep narrow sections. And you would come along and say 'What

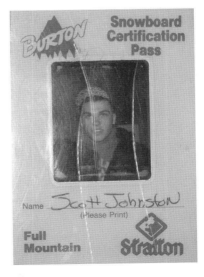

All riders received a lower mountain and then a full mountain certification. *Scott Johnston.*

the *&%^ happened here! Son-of-a-bitch, those damn snowboarders!'" In time, the skiers tried different approaches to keeping their backwoods trails to themselves—long traverses, alternative entrances—"We tried everything short of setting snares."[26] Scott Richmond also looked back with humor: "The ski industry kind of forced us to ride together because it was dangerous not to. There were people who hated us. We would ride down the mountain, people screaming and swearing at us from the lifts. People blaming us for messing up the mountains, and we're pushing all the snow off. We took a lot of grief from a lot of people."[27]

Paul Johnston saw the irony in the certification program. When he observed the lessons area, Johnston saw "Forty to fifty kids learning how to snowboard right next to forty to fifty kids learning how to ski." He continued, "There was no difference. They were all beginners. And all of a sudden, I started laughing. I got all this control over snowboarding. But I have no control over anyone…that brings his friends skiing the first time, takes him to the top of the mountain, goes bombing down and hits people."[28] Mitchell quickly received a lower mountain certificate, but the upper mountain was considerably harder to attain. While repeatedly denied upper mountain certification, he does not hold a grudge. "When you look at snowboarding now and you look at it then, it was hard to snowboard then." Mitchell continued, "Now, they make snowboards so easy to ride, that's why people pick it up so quick. Back then, it was a workout to snowboard."[29]

During this first season, Andy and Jack Coghlan came down from Burlington to snowboard Stratton (officially) for the first time. Although Andy was a member of the Burton Pro Team, "it didn't matter, you had to get certified," remembered Jack Coghlan.[30] Mark Heingartner was not around that day, so the Coghlans met up with an instructor, hiked up Suntanner and demonstrated their ability to check speed and put together a series of turns. Coghlan continued, "We get down, and the instructor said, 'Alright, you passed.' He started asking questions, and then Andy's like, 'You know I am the U.S. Open Champion.' And the instructor said, 'Yeah, sure you are.'"[31]

The old clocktower served as the snowboard program's board storage, office and hangout. "That was our home base," Heingartner recalled. It was the home for all the demo boards, the money box, certification cards, the tuning room and a makeshift office consisting of beach chairs. The boarders initially shared the space with the adaptive sports program, but "our program became bigger pretty quick and we more or less took it over." While a small space, "looking back, it was a decent location because it was in the middle of everything."[32] The clocktower years were short-lived, and

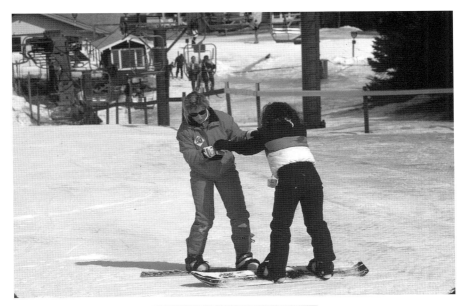

Above: A rider needed to be able to turn both ways, come to a complete stop and ride a lift in order to receive certification. *Hubert Schriebl.*

Left: Mark Heingartner first rode backcountry with Carpenter, then worked for Carpenter on the slopes and in the office. *Burton Corporation.*

when the program was taken over by Stratton, the clocktower home base closed. "We were having too much fun. Like we would be outside playing hacky sack," Matt Mitchell continued. "They just didn't like the thought that we were unstructured. Meanwhile, everyone got their lesson, we were always on time."[33]

BROTHER

When Steve and Mike Hayes lived in New York, they often visited their neighbor's house in Stratton. One spring, they came across two Snurfers in the garage and a little patch of snow. This mid-1970s exposure served as a launching board for a lifelong passion. When their family moved to Stratton in 1979, the two started off as skiers, participating in the freestyle ski program. After skiing during the day, they rode the mountain at night. Using their own Stratton backyard, Mike Hayes recalled in 2017, the two hiked up and "would go down and hit a snow bank and do a flip off of the board. And that was the trick—if you can do a flip and not land on your head."[34]

The Hayes brothers poached Stratton long before the certification program commenced. Steve often got rides to the top of North Brookwood road and "come Snurfing down to Snowbowl lift and jump right on and tell the lifties 'it's all good. The ski patrol told us it was OK for us to ride the whole mountain.'" Steve Hayes continued, "And then we get spotted, and they would send out a chase committee. And fortunately, we dodged them and got off the mountain without getting into any kind of serious trouble. But the word got out that there were snowboarders riding on the lifts."[35]

Once Carpenter and Johnston started the certification program, the Hayes brothers had to deal with the new authority. One day, Steve Hayes was giving snowboard lessons to three fellow Stratton Mountain School classmates. When Steve arrived at the bottom, he was met by Jake and PJ, who "were standing there with their one-piece suits with their arms crossed. They were like 'we are trying to set up a program here at Stratton, and you can't just go up and snowboard.'" This was news that did not go over too well with Hayes, and he promptly told Jake and Paul "to go *&%^ themselves." Hayes explained, "I've been snowboarding at Stratton for five years, and I didn't give a shit what the hell they're trying to do. I'm out here trying to have some fun with some girls from Stratton Mountain School, and we can

Mike Hayes was part of the Stratton freestyle ski team before taking up snowboarding. *Hubert Schriebl.*

Right: While attending the Stratton Mountain School, Steve Hayes snowboarded every free chance when not ski racing. *Hubert Schriebl*.

Below: Mike Hayes (*left*) and his brother were the first riders to get certified for the upper mountain. *Burton Corporation*.

Early boarders faced the challenge of wood boards with metal skegs. *Woodruff family*.

do whatever we want. So that didn't go so well."[36]

After taking certification lessons from Mark Heingartner in 1984, the two were "the only ones with full mountain certification for a long time....We were pretty proud that we had the full mountain sticker on our passes."[37] During this time, Heingartner regularly provided the Hayes brothers with lessons and new equipment, allowing them to demo the latest boards. Soon thereafter, the two joined the Burton team, competing at the first U.S. Open in 1984. Steve attended the Stratton Mountain School for alpine ski racing, then made the conversion. Mike and Steve then went to school at the University of Vermont. Steve recalled, "I was the only pro rider who was going to college during the off-season....It took me a long time, but I'm sure glad I had an education to fall back on....I actually managed to get through college and graduate....That wasn't easy. I would do summer school and do the fall semester and then take off the spring semester and compete."[38]

"We were little smart-ass kids at Stratton Mountain. When people asked us about snowboarding, we didn't really care," Steve Hayes recalled. "We understood to be sponsored was to promote snowboarding, but we didn't really give a shit about what people thought about us." When Mike and Steve were in the lift lines, surrounded by skiers, they had to field endless questions about their curious contraptions. "In the beginning, it was so many questions from so many people that it got so tiresome that we were just giving snappy answers." Steve explained a few games that the brothers played on the inquisitive skiers:

> We would give them the "yup treatment," where every question they asked it was just "Yup." "Is that fun?" "Yup." "Is that hard?" "Yup." "Does that take a long time to learn? Yup." And then we got a little more creative, and people would say, "Is that fun to do?" And we say "No, it's really hard. But my

Steve Hayes catching some spring air. *Burton Corporation*.

mom thinks it's going to be in the Olympics someday." The funny part about it was my mother never thought it would in the Olympics. She told me that I should give up my snowboarding and I should just focus on school.[39]

The Hayes brothers found themselves at the dawn of a new era—they were pro snowboarders at a time when there weren't many riders and the sport was still a curiosity. "That's where the lifestyle and attitude of 'I don't give a &*%^ about anything' really came," Steve said. "It was such a special time and a special place with special people that really was amazing because snowboarding was so new. No one knew where it was headed, what it was going to be like."

MOVE OVER

The National Snow Surfing Championships moved to Stratton Mountain in 1985 and was renamed the U.S. Open Snowboarding Championships. While Stratton embraced snowboarding, it was the closing of Snow Valley that necessitated the change. Carpenter recalled that "Stratton was cool

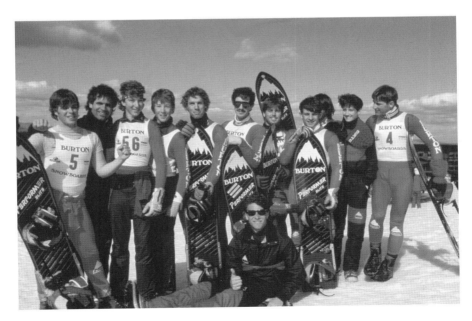

The 1985 U.S. Open at Stratton Mountain. *Hubert Schriebl.*

Laurie Asperas and her wild outfits challenged the Bogner attire of the Stratton Mountain skiers. *Hubert Schriebl.*

enough to let us ride here and have the event here, so the Open was back on....For a while there, we had no place to do it. It was an emergency crisis situation but it worked out—Stratton rescued us."[40] The U.S. Opens between 1985 and 1988 were dominated by the likes of Andy Coghlan, Mark Heingartner, Tom Sims and Craig Kelly. A head turner at these early U.S. Opens was Laurie Asperas, a Long Island native, who was a model, teacher and an early challenger to the orthodox alpine fashion. It was almost as if she was the vanguard for the West Coast fashion invasion. One Easter, Hubert Schriebl captured Asperas snowboarding in shorts and a Hawaiian shirt. The photo did the 1985 equivalent of going viral, hitting the pages of the *Daily News* and *Newsweek*. After seeing the picture, Carpenter wrote her a letter "saying that I should quit my teaching job and come work for him. He said specifically that I was going to really help the sport, because we were outlaws and it was illegal at the time. I really took that on. I was like 'He's right; I can do this.'"[41] Substituting riding chaps for ski pants, Asperas was putting an exciting face on snowboarding as she represented Burton in Colorado and Europe.

Meanwhile, back at the Snow Valley, the closed mountain continued to serve as a powder haven to the locals. The base lodge remained standing as is for many years, almost eerily, as the glasses remained on the tables and the Galaxian video game sat unplayable. Despite the closure, the mountain lived up to its name, remaining in a snow belt and providing fresh powder for countless backcountry boarders.[42] In 2011, a fire claimed the Fritz Dillmann–designed base lodge, and in 2017, only a chimney remains as a monument to the competitor camp outs, keg parties and awards ceremonies.

3

GROWTH

SNOWBOARDING ORGANIZES AND EXPANDS

LESSONS TO ME

After the success of Burton's snowboarding school, Stratton realized snowboarding's future and wrestled control of the education program from Burton, transferring lessons to the Stratton Ski School and Allegro Program. Stratton also eliminated the certification program. The lawyers reentered the scene and realized that the certification program could backfire. Through a certificate, the mountain was "saying I'm good enough to be up there and I hurt myself. Now it's your fault."[1] In the end, the program helped snowboarding in its acceptance by the ski industry. It also served as an incentive for the riders to work at the sport. In the end, there were skilled riders representing the sport and not a great wave of out-of-control boarders. It was a crucial public relations move.

Suzi Rueck, a graduate of the Stratton Mountain School, developed Stratton's snowboard program, the Allegro Program, in 1989. During her tenure, riders such as Tricia Byrnes, Doug Byrnes, Jay Fusco, Ross Powers and Russell Winfield passed through the weekend-based program. She was also joined by Doug Scanlon, Kurt Meyer and Brew Moscarello. They spent the mornings running gates and then headed to the half-pipe in the afternoon. Every now and then she had the riders hike to the top before the lifts opened. Since she made them hike without their boards, they did not get the reward of riding down.

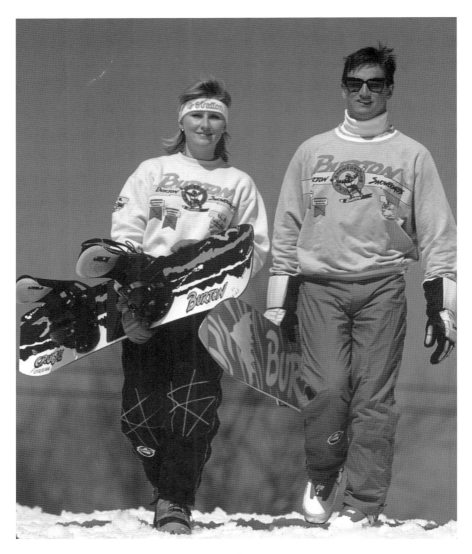

Suzi Rueck and Mark Heingartner, through the Allegro Program, introduced many future competitors to the sport. *Hubert Schriebl.*

While living in New Jersey, Matt Mitchell called Brew Moscarello at Burton seeking a job building boards. Moscarello steered him toward Rueck, who had "only five full time instructors."[2] Mitchell dropped everything, found a ride to Vermont and "showed up, no driver's license because it was suspended, on her doorstep with a suitcase, a Nordica boot bag and a board

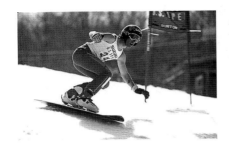

Matt Mitchell was a fixture on the snowboard scene day and night. *Hubert Schriebl.*

bag." The ensuing conversation went along the lines of "'I'm here for the job'…'You don't have the job, you have to try out'…'No, I'm here for the job.'"[3] Rueck brought Mitchell on, and she "made a deal with me, if I work every day during the week, I could race on the weekends."[4] While the Allegro Program served as feeding system for racing, "a lot of them were kids.… They needed basic snowboarding skills even more than racing skills."[5]

When her brother Doug Byrnes started snowboarding, Tricia Byrnes wanted what he had:

> *They…got into snowboarding and so I just wanted to chase them around.…It was like the first year of the Allegro Program.…I saw all those guys cruising around, running gates, doing cool stuff, so I just wanted to join them. And there's this one other girl on the mountain that was snowboarding; her name was Beth Trombly, and we ran into each other the base lodge, and were "Do you want to join?" We teamed up and then decided to join. We were the only two girls in. And it was back in the day when if you saw someone on the snowboard you were like "Oh my god! Hi! You're the other person out here snowboarding." You knew everything single snowboarder because there were twelve of you.[6]*

Englishman Neville Burt was teaching skiing in France prior to coming to Stratton. Burt arrived as a skier who also knew how to snowboard. After the departure of the Burton program, there was a makeshift Stratton program that had limited success. "I looked at Alois Lechner [Stratton Mountain Ski School director]…and said 'Do you really enjoy having Jake down at your school desk taking all your income?'" said Paul Johnston in 2017. "Because, from a beginner's standpoint, we were selling more beginner snowboarding lessons than we were alpine beginning lessons."[7]

In the mid-1990s, Alois Lechner placed Burt in charge of the program. Burt remarked in 2017, "It was a shit show to be quite honest. But it was fun."[8]

During the early days, there was a rift between skiing and snowboarding. *Stratton Foundation.*

The small program faced a massive influx of beginners, a small number of coaches and a limited number of rentals. Burt created the Night Rider Program, which provided night lessons under the lights on the Tyrolean trail. On weekends, the snowboard school sold out regularly, and the small squad taught over one hundred beginner snowboarders. With staff being the biggest challenge, Burt approached the challenge by creating one massive group lesson—"We would set up stations. Once they mastered one piece of this, they would go to the next station and go to the next station."[9] Instead of students having a single instructor, they would have five different instructors teaching one aspect of the sport. The next stage in the education was the creation of the Learn to Ride Program. Done in conjunction with Burton, which made convex learning boards, this program greatly improved the beginner process. Through the special boards, the Stratton instructors "changed the methodology of teaching because everything up to that point had been borrowed from skiing." Burt continued, "We wanted to get out of that lock step, ABC, 123 methods of skiing, and we went to more conceptual stuff."[10]

With Stratton's deep Tyrolean tradition within the ski school, the snowboarding culture was stark contrast. One of the first real clashes of sporting cultures within the ski school was the daily lineup. Every morning, the instructors lined up, with skis on, waiting to receive their morning students. Ski school director Alois Lechner wanted the snowboarders to do the same. Brew Moscarello recalled Lechner as "a hard ass Austrian." Moscarello "always felt that program needed to be in the hands of a snowboard director and not a ski director. It's just the nature of the beast....But in those days, it had to meld together."[11] It didn't take long to realize that snowboarders could not assimilate because standing while strapped in was not easy task. "Then he relaxed to it and by the time he saw we were running our own show, he was fine and he just let us get on with what we were doing." When Stratton adopted a snowboard program, the instructors left the clocktower

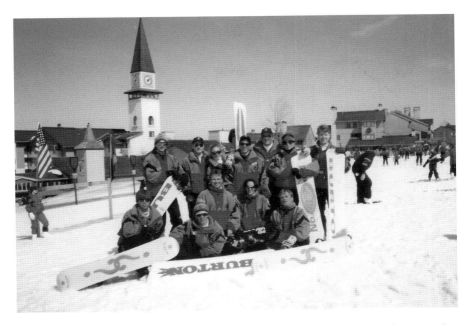

After a few years of Burton providing mountain certification, Stratton Mountain assumed control of snowboard instruction. *Neville Burt.*

and entered the ski school building, where it wasn't exactly kumbaya. "You had to walk past everyone to get to our lockers," Matt Mitchell remembered. "They stuffed us in this tiny little corner like we were a red-headed stepchild. It was crazy. They just hated us being in there."[12]

Once Alois Lechner hired snowboarding instructors, according to Paul Johnston, "he made the biggest mistake he could have ever [had made]." Lechner made the riders wear the traditional ski school uniforms "instead of going out and buying them a uniform that was more appropriate to wear when you're snowboarding." Johnston felt that Lechner could not "get through his head that you needed more flexibility in your clothing."[13] The following year, the riders were given appropriate clothing, another small step in the evolution of snowboarding as an autonomous sport. Neville Burt recalled with a laugh, "It was quite amusing. It was not quite goose stepping, but it was pretty darn close. We had German eagles on our sweaters, and we had to wear white polos....We fought so hard and we got our own uniforms, which were terrible, but we got them anyway."[14]

With many of his staff competing in the U.S. Open and other events, Burt did his best to accommodate their schedules. A time-honored, and often

abused, tradition at Stratton is becoming an instructor to get a season pass. Seth Neary became an instructor with the goal of a pass, but he "was the guy that showed up maybe a dozen times to the lineup and then got the letter the next year saying 'Thank you, don't apply again.'"[15] At times, Neville Burt was a disciplinarian. "Stratton is small enough mountain, you hear back from those instructors that wanted time off as well," Burt explained, "They would say 'Hey, I saw so-and-so in the Sun Bowl woods.' I just electronically turned the pass off. Then they had to come see me to get it back."[16]

There was an uneven pay scale between snowboarders and skiers. This was not because of a rivalry between the two but rather a lack of a snowboarding instructor certification program. Through the newly created American Association of Snowboard Instructors, Burt teamed up with Brian Spear in 1998 to write a certification manual for snowboard instructors. "Together we wrote the manual based on what we had learned travelling around. It was written right there, right at Stratton," recalled Burt. The two spent every afternoon down at the Outback Bar and Restaurant, creating a manual that was an important step in legitimizing a new sport. The manual stood the test of time and is still being used today. "I am pretty dyslexic," laughed Burt, "We actually got two awards….We got a silver award for technical literature on that thing."[17]

A FAMILY AFFAIR

Two mainstays at Stratton were siblings Tricia and Doug Byrnes. They embraced snowboarding at an early age, and the mountain witnessed the duo rise from youthful rippers to ranked competitors. The two came to Stratton after their father caught the skiing bug. "My dad learned how to ski when I was ten…and he fell in love with it," Tricia Byrnes related in 2017. "We went to Stratton over Christmas vacation, and it was pouring rain and he did not want to go. And all of a sudden, he got totally hooked, and was like 'This is the best thing ever. We're a ski family now.'"[18]

Their parents were early advocates for allowing snowboarding at Stratton. They often visited Paul Johnston and said that their children "used to ski race and got burnt out….'Are you ever going to allow snowboarding here… so the kids can have something else besides this?'" Mrs. Byrnes would say, "You know they used to be the first ones in the car to come up to the mountain, now they don't want to come to the mountain anymore." Johnston

concluded: "The minute I allowed snowboarding, they were tickled pink. The kids started enjoying the mountain and Stratton again."[19]

Starting in 1980, the Byrnes siblings were regular fixtures every winter weekend. Doug Byrnes had a room in his parents' house that served as a popular hangout. Neil Korn added, "A lot of people would come and visit him….We always went there to look at magazines, and he was getting into playing music so he would be on the turntables. He always had a lot of memorabilia from U.S. Opens on his bedroom walls."[20] Alexei Garick and Doug Byrnes had seen each other on Stratton, solidifying their relationship when they met at Western State Colorado University. The two eventually migrated back to Vermont during a winter term, living in the basement and snowboarding as much as they could.

In 1999, the Vermont snowboard world lost Doug Byrnes when he died of an asthma attack. Alexie Garick recalled Doug: "He was my best friend for a very long time. My number one riding partner…absolutely amazing kid…a lot of love. Just an amazing guy."[21] To Alvah Wendell, "he was so kind and generous…rough in appearance, but so genuine….Few have ever lived that loved snowboarding as much as he did."[22] Matt Mitchell felt that Doug "didn't say a whole lot, but [he was] very intense. Snowboarding for him was

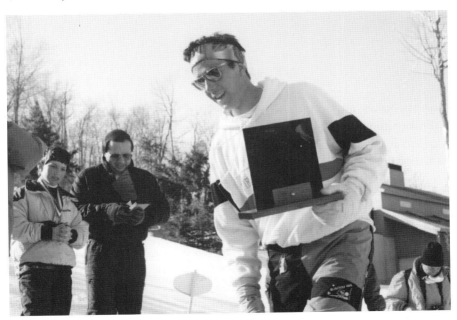

While his time on this earth was short, Douglas Byrnes had a profound effect on those blessed by his presence. *Tricia Byrnes.*

a religion. He didn't care if he was riding with a bunch of people. He just did his thing. He wasn't worried about what anybody else was saying. I took a lot from that. Don't worry about what everyone else is doing or saying, just worry about yourself." Seth Neary recalled, "He was just an amazing spirit. He was the face of snowboarding for Stratton. He would ride with anybody. He never vibed anybody. You were always welcome to hang out at his house with his turntables and meet his family. He was an awesome friend."[23] Beth Trombly Renola added, "He was super cool, very quiet. He wasn't really like all the other loud snowboarders. Everybody really respected him. He had this very quiet humble way. He was never a show off or anything like that. I don't think he would brag about himself."[24]

To honor Doug Byrnes, Stratton dedicated a new terrain park, East Byrnes Side. This section of the mountain was the location of the earliest terrains parks and the first U.S. Open half-pipe competitions. While memorializing Doug Byrnes with the trail was a beautiful moment in Stratton and snowboarding's history, the unrealized story was that the dedication reflected a larger trend. The slope was formerly called Tink's Link. One of original seven Stratton Mountain trails, it was named in honor of Stratton founder Tink Smith. While changing the name honored one member of the Stratton community, it inadvertently erased an homage to an earlier community member. In some regards, the name change represented the downturn in skiing and the rise of snowboarding. It also represented a generational passing of the baton.

Doug's sister, Tricia, carried the snowboard torch for her older brother. She is known as a "down-to-earth and girl-next-door, with an infectious smile."[25] Tricia started off with skiing while Doug was at the forefront of the fledgling snowboarding movement. According to her mother, Tricia abandoned her skis for her older brother's world when "she decided she'd have more fun with him and his friends."[26] She went through the certification program with Chris Molello and, in 1988, joined the Allegro team. Tricia owed her exposure to Doug: "I wanted to be cool and try it, too....In snowboarding, I feel totally, totally blessed and so lucky. I'm here today and enjoying snowboarding so much because of who my brother was."[27] "Trish was like our kid sister....She was always there with us and it was awesome," remembered Seth Neary "She looked up to him. He was such a good brother to her. It was such a good relationship. They were the youngest in their family, and I never ever saw them have any words. They were so close."[28] Beth Trombly Renola added that Doug "definitely looked out for her [Tricia]....They were extremely close, very tight."[29]

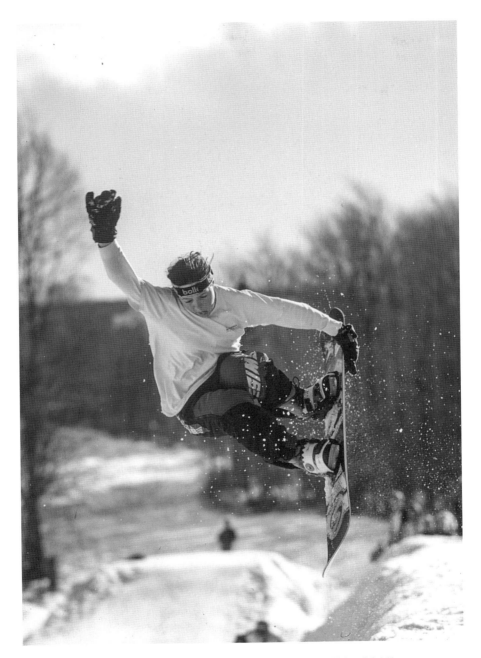

Tricia Byrnes rose from the certification program to Olympian. *Hubert Schriebl*.

With her brother's assistance, Tricia became "as good as all the guys."[30] She won the women's half-pipe at the 1992 U.S. Open. The year that Doug died, FIS ranked Tricia as the overall number one half-pipe female rider in the world. She won the World Championship, and America selected Byrnes to the country's representative America for the 2000 Goodwill Games. During her career, Byrnes won fourteen World Cup victories. She then attended St. Michael's College. Tricia represented the United States at the 2002 Olympics, and the U.S. Olympic Committee chose Byrnes to be in television ads "promoting the training dedication of its athletes."[31]

WEEKEND WARRIORS

To provide a competitive forum for regional riders, Chris Karol and Andy Coghlan developed the New England Cup (NEC) in 1987. The two put a rule book together, while Karol met with ski areas. For so many of the young riders, participating in the New England Cup was a logical progression. Racing in the NEC "was just all part of the stoke," commented Beau Thebault. "We are riding on mountains. We're on the same terrain as skiers. We're keeping up with skiers....I was like 'Wow, I'm doing this here, and there's a competition here...I want to get involved.'"[32]

The Allegro Program was the training program for Rueck's other endeavor, the Green Mountain Series (GMS), a stepping stone to the New England Cup. Rueck approached Tricia Byrnes and said, "You need to enter this race!" "Byrnes's response was 'What? Are you crazy?'" Despite initial trepidations, Tricia and Beth Trombly heeded Rueck's advice, and according to Byrnes, "That was the end of my life or the start of it." The GMS "gave kids the way to get into the New England Cup at the time," Matt Mitchell commented, "There was nowhere for anybody to go. If you went to the New England Cup, you were thrown in with the local pros....For someone like Ross Powers, there was nowhere for him to start at eight years old. It didn't exist. That's why she did it."[33] Primarily hitting the road for weekend races, the GMS found this cadre of snowboarders traveling up and down the state and other parts of New England. These races proved essential for the competitors. "She [Suzi Rueck] was the mom to a lot of us," Seth Miller recalled, "giving us all the opportunity to compete."[34]

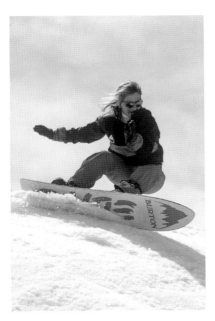

Suzi Rueck led the Stratton Mountain Allegro Program, giving future Olympians Byrnes and Powers early competitive training. *Hubert Schriebl.*

In the early 1990s, Ian Price attended Greenwich School in Putney, Vermont. Given Fridays off, Price and his fellow classmates went to Stratton to ski or snowboard, with the caveat that they had to take lessons. Price met Stratton instructor Doug Scanlon, who convinced Price and his classmates to participate in the GMS. The following winter, Price and two others, with the help of a generous mother, participated in the weekend races. Joining the ranks of many a hockey mom, this mother drove all the way from Bennington to Putney, brought them to the races and back and then returned to Bennington.

When Seth Neary lived in Bondville, his house struggled with finances. When the GMS added a pro division, many saw an opportunity to pay the electric bill or treat themselves to meals. Paying $80 to enter the race, Neary lobbied for more entrants in order to increase the prize pool. "You would try to get as many people in it, and then you would try to win." Neary continued, "I was living check to check basically off of that—$80 per event, and your take home for first place was probably 150 bucks, so you get your 80 bucks plus whatever. It was a gamble. It was total gambling."[35] "We used to just make our entry fee and would be 'Oh shit! We have no money for lunch. What are we going to do?'" recalled Scott Johnston. At one competition, his brother "got two cups of hot water and got six packets of ketchup. Then he squeezed six into one cup and six into another and pepper and salt and crackers and we had tomato soup. That was our lunch for the day because we didn't have any money because we made our entry fee with all the money we had."[36]

While Ross Powers earned his snowboarding wings at Bromley, he eventually made his way to the GMS. Prior to Powers' first race, his mom talked to Kurt Meyer, a Bromley instructor. She allowed Ross to skip school to work with Meyer—"all he could find at the time was some bamboo poles, and he set up some…so I could try to get the feel and the going around some gates."[37] Ross then talked with Rueck and Paul Johnston,

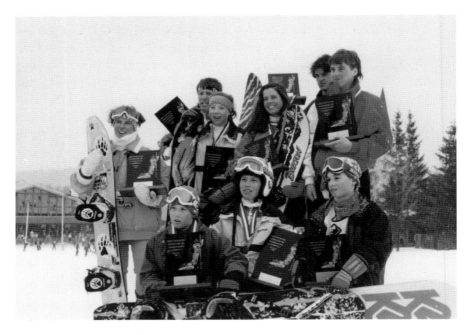

The Green Mountain Series was an opportunity for many local snowboarders to compete. *Tricia Byrnes.*

who provided assistance for Powers to join the Allegro Program. Powers recalled that "they made it very affordable because my mom had a very small income to make it so I could train."[38]

The GMS served its purpose as a farm system for competitors. Ian Price reflected on the endless list of names who passed through the hallowed gates of the GMS: "There's so many good riders that came out of it that is kind of mind-boggling when you look back at who grew up in the Green Mountain Series and what they you know what they continued on to do."[39]

PATHFINDERS

Mark Heingartner and Andy Coghlan were the first East Coast snowboarding stars. When Carpenter was building boards in the basement of the Birkenhaus, the three of them tested prototypes by making evening sojourns up the mountain. Carpenter credits the Coghlan brothers and Mark

Heingartner for moving the sports toward hard-packed snow. Carpenter was a backcountry fanatic, but his younger cohorts were "a little bit lazy for that" and were kids "who just wanted a rush."[40] It was the shuttle trips up and down Bromley Mountain, prompted by the kids, that pushed Carpenter toward the groomed trails, "and we started figuring out how to ride in the hard pack."[41] In a 1989 *Skiing Magazine* article, Carpenter also credited Coghlan and Heingartner for approaching Stratton: "It wasn't my idea to go to [a] ski area," as Coghlan and Heingartner "dragged" him to Stratton.[42] The boys gave Carpenter a much-needed fresh look on the industry. Carpenter had "been beaten down and experienced so much rejection," and the Coghlans and Heingartner had "pureness to their approach" that was refreshing.[43]

They were both U.S. Open champions and instrumental in teaching the world about the new sport. After winning the U.S. Open, Coghlan uttered words that influenced countless future competitors: "Bored skiers go snowboarding."[44] This mantra brought Coghlan, Heingartner, Hayes, Byrnes, Eberhard, Shaw and so many more into the world of snowboarding. It also made Paul Johnston open his eyes to the possibility snowboarding. "Andy Coghlan was the big force there," Mike Hayes said. "Everyone respected him because he had done so well and he had been doing it longer than anybody."[45] Heingartner believed that besides his ski background, a lot of Coghlan's success "was because he thought he could do it and knew he could do it, regardless. He had that right head for 'I am going to be the fastest one from top to bottom.' He had the right edge."[46] Coghlan ended his competitive career with six U.S. Open championships, and he continued to make his impact felt on the sport through his work in the Burton factory, his Boarding House Snowboarding shop in Burlington and his ongoing dedication to coaching future snowboarders (as well as an annual indomitable basketball team).

The second-generation boarders looked up to Andy and Mark. The beauty of the early competitions was that a teenager had the opportunity to compete

Andy Coghlan dominated snowboarding competitions throughout the 1980s. *Hubert Schriebl.*

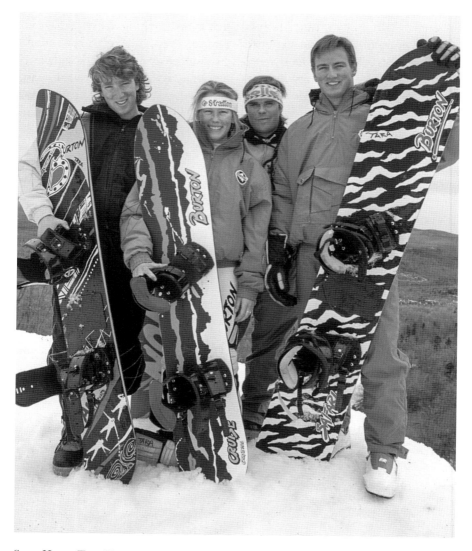

Steve Hayes, Tara Eberhard, Andy Coghlan and Mark Heingartner. *Hubert Schriebl.*

with the forefathers. Due to the bracket dual slalom format, an up-and-comer often ended up in the finals with a no. 1 seed. "One of my favorite race runs was a dual song against Andy Coghlan. It was a nasty gnarly, rutted out, slalom course," remarked Beau Thebault. As a lower seed, he found himself head-to-head with the man who had certified him years earlier. Thebault

continued, "Prior to our run, Andy was giving me coaching....I stayed within a couple of gates of him, and afterward he said, 'I could hear you the whole time. Nice run.' For a sixteen-year-old kid, that was awesome."[47] It was a testament to the accessibility of the sport, the intimacy of the competitors and ultimately the character of Coghlan. He was a coach before he was a competitor. Ross Powers recalled one incident when Coghlan "gave me Burton white gloves with the blue pads for gate bashing....That was like the coolest thing back then [when] we were kids."[48]

Mark Heingartner first tried a snowboard at Sugarbush in 1978, long before making southern Vermont his home. The Heingartner family, with Chuck and Keith at the helm, operated Kinney Motors in Rutland, which sponsored several of the first U.S. Opens. Mark Heingartner first visited the Londonderry factory with a gift certificate for Carpenter's Safari program. "Jake would bring you out back hill riding," Mark Heingartner recalled in 2017. "That was one of his angles of getting people out on the snow. Shortly thereafter, I started hanging out with him....I was kind of like the little brother and he started bringing me out riding."[49] Heingartner brought a love of skateboarding and surfing to the snow, "so I took to it straight away and really liked it early on, I was one of his go-to guy to go riding with."[50] Jason Ford was skiing at Stratton and remembered "sitting on a chair lift on Suntanner and seeing Mark Heingartner, didn't know him at the time, riding down on Suntanner, hitting those rollers and doing airs, I thought it was the coolest thing ever."[51]

MAINSTREAM

SNOWBOARDING LEAVES THE FRINGE

ORGANIZE!

When the U.S. Open arrived in March, the Burton offices closed down, and "everybody would go up there and we'd all have a job."[1] Employees found themselves either gatekeeping, announcing or timing. "When the U.S. Open came around, pretty much everybody that can work at the Open, worked at the Open," recalled Scott Richmond.[2] For Richmond and Paul Wren, their computer skills translated to timing and scorekeeping duties on the mountain. John Thouborron managed the event, running around with multiple radios, serving as the intermediary between the Burton and Stratton communication systems. Working with Stratton Mountain staff, Paul Johnston, Andy Foster and Skye Foulkes, the U.S. Open, for Thouborron, was a time-consuming part-time job. The planning for the Open began immediately after the completion of the event with a wrap-up meeting. "We probably had two meetings over the summer-fall," Thouborron recalled. "We started meeting regularly much more regularly as it got closer. I moved up there to Stratton about three to four days before the start of the event and was there right through the event"[3] Like so many aspects of the sport, there were growing pains. Mike LaVecchia and Shem Roose were in charge of registration one year, and the room was "swamped with competitors. They overran the registration desk. That was also a year where we also got swamped with media. Probably three or four times the amount of media

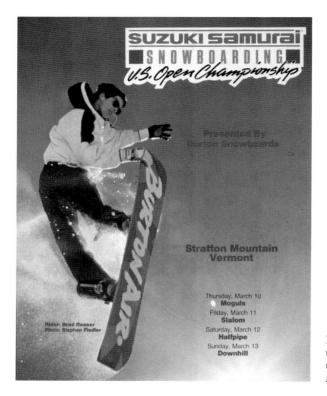

During the 1988 event, the U.S. Open introduced the half-pipe competition. *Burton Corporation.*

we expected. It was kind a wakeup call year."[4] Years later, Shem Roose took responsibility for the chaos: "I entered something wrong in the program. I can't remember all the details, but all I know is that the bib numbers were totally messed up and it was pretty stressful. I definitely made a mistake and JT was stressed and we had to figure it out the day of registration."[5] In addition to dealing with the increased numbers, there was also an increased demand from the competitors. Thouborron continued, "There were a lot of competitors...foreign competitors were coming into town. A lot of angst about running order and the legitimacy of seeding and things that the U.S. Open hadn't had to deal with up to that point."[6]

In 1988, amateur surf coach Chuck Allen created the United States Amateur Snowboarding Association (USASA), the first governing body for competitive grassroots snowboarding. The organization standardized rules of competition and held an annual competition. Gordon Robbins, a.k.a. "Grandpa Shred," was a co-founder of USASA. He also served as executive director of the International Snowboard Federation, technical director of the U.S. Open and president of the USASA. A resident of Bondville, Gordon

and his wife, Claude, often hosted dinners and USASA meetings. Robbins was a fixture at the U.S. Open, positioned at the top of the pipe. Mike Mallon recalled, "He was always keeping it light and always encouraging the kids. 'Have a good one,' he'd say, or 'The pipe is all yours.' He has probably high-fived every icon in snowboarding at least once."[7] Gordon Robbins died in 2015, leaving a large cache of competitors and coaches who benefitted from his wisdom and guidance.

Prior to an early U.S. Open, Carpenter addressed the competitors: "What you got to remember is that you are the sport....I want you to think about the spirit of this competition. There is going to be a lot of press here. Remember—you represent the sport."[8] James Tabor of *Ski Magazine* wrote at the time that Carpenter's words were a "curious little speech, part pep talk and part behavioral admonition, as if half had been written by a high school principal and half by a football coach." With this speech, Carpenter demonstrated an early drive to take snowboarding to a level of respect and professionalism. Carpenter writes in the book *To the Extreme* that "overcoming the ignorance and prejudice—epitomized in such humorous words as 'knuckle dragger'—was a process that required solid education, professionalism and persistence."

DAY GLO NATION

With sales, skier visits and ski resort acceptance increasingly dramatically in the 1988–89 season, the competition at the U.S. Open also went through a profound change. David Alden wrote in *Snowboarder Magazine*:

> *Sponsors quickly learned all they had to do was dress us up in Day-Glo and catch somebody no camera saying, "gnarly air, dude," and they were guaranteed 15 seconds on the evening news. We all knew that the sponsors and the media had no idea what the sport was about, but if dressing like clowns and posing for MTV meant a few days of free riding, most of us were in.*[9]

With neon ruling the fashion of the day, Terry Kidwell, Bert Lamar and Craig Kelly were the top three finishers in 1988. Jason Goldsmith attended the competition as a spectator and said to himself, "Oh wow this is going to change everything." Goldsmith continued, "Pipe riding was in its infancy.

By the 1991 U.S. Open, the competition had risen from local curiosity to an international event. *Brian Knight.*

The pipe hadn't gotten that big yet. Two years later, everything was iconic."[10] In the 1989 U.S. Open, Kelly and Lamar finished first/second in the half-pipe. While neon remained the fashion choice, Lamar graced the podium with a beaded hairstyle reminiscent of Bo Derek in *10*.

The 1988 U.S. Open was well attended, as it drew larger crowds than the pro skiing races held that same winter. Despite this turnout, a January 1988 *Parade Magazine* article listed snowboarding as 1988's "worst new sport."[11] The article stated that according "to traditionalists, the breezy fad is a clumsy intrusion on the sleek precision of downhill skiing."[12] In 1992, the magazine bestowed the same honor to lawn mower racing. While this sport did have a governing body, the U.S. Lawn Mower Racing Association, it certainly did not have the cultural impact like the earlier award recipient.

THE RACE IS ON

While the half-pipe emerged, there was a whole slew of converted Vermont ski racers making their impact on the U.S. Open events. After working for Burton in the early 1980s, Scott Palmer earned a scholarship to Johnson State College for ski racing. After three years of intensive skiing, Palmer returned to snowboarding, as "all my buddies started making money going to these snowboard races every weekend, so I started snowboarding again."[13] At this time, he participated in Coghlan's New England Cup: "I was just bumming around in Burlington working at Andy's snowboard shop and sleeping on his floor."[14] Following a good showing in the 1988 U.S. Open, Burton sponsored him, and he raced on the Pro Snowboarding Tour of America.

Tara Eberhard was a top ranked snowboarder at the time. She attended the Stratton Mountain School, where she trained daily—in alpine skiing. Eberhard followed a common narrative and converted to snowboarding

Tara Eberhard transitioned from ski racing to snowboarding. *Hubert Schriebl.*

because she "got bored with skiing" and "wanted to do something different."[15] She was a role model for young female snowboarders. Eberhard felt that snowboarding "was wide open for women" and ideal for "women who like to be different and stand out in a crowd."[16]

Manchester resident Betsy Shaw first put on skis at age three. Taking advantage of local programs such as the Junior Instructional Ski Program (JISP) and the Bromley Outing Club, Shaw embarked on a downhill ski racing career. She skied at Manchester's Burr & Burton Seminary as well as the University of New Hampshire. Shaw's snowboarding inspiration came from a hot day at the U.S. Open where "the girls were pulling their speed suits down and they had bikini tops underneath them and the girl came down and won." After the scantily clad victory, Shaw realized, "Oh my god! I'm in the wrong sport!"[17] At first, Shaw wasn't "on a mission to compete, I was on a mission to get good at snowboarding because it totally chewed me up and spit me out. I thought I was going to learn really fast, and it was hard at first. I was so determined to keep doing it and get good at it."[18] Soon enough, Andy Coghlan convinced her to enter a race. She placed second and caught the bug. "I was in college and I thought 'well this is an interesting way to make some money on the weekends.'"[19] Shaw eventually joined the World Pro Snowboard Team coached by Rob Roy, bringing her snowboard experience well beyond the confines of southwest Vermont. In the early 1990s, she helped recruit fellow Manchester resident Ian Price to the team. Fresh out of high school, Price listened to Shaw in his parents' house, and he responded, "'All right cool. That sounds good.' I didn't know. I was so young and impressionable."[20] His parents also helped the decision-making process, as they offered to "pay for you to go to college or for your first year on a pro tour snowboarding." Price did not see much dilemma and said to himself "That's a no brainer....I am going snowboarding."[21]

Manchester native Betsy Shaw represented the United States at the 1998 Nagano Olympics. *Hubert Schriebl.*

PIPER

In 1983, the Soda Springs Ski Bowl in California hosted the first snowboard half-pipe contest, with roots in skateboarding the empty pools of California. The alpine-oriented Burton team threatened to boycott the competition because they saw no connection between the two disciplines. Similarly, during the 1984 championships at Snow Valley, many West Coast riders were caught off guard by the alpine format. While part snowboarding xenophobia, the half-pipe planted firm roots, and a boycott was not going to thwart progress. The 1988 U.S. Open featured the inaugural half-pipe, which was "spectacular and acrobatic" and immediately became the "media darling, the big draw, the wintertime version of skateboarding."[22]

Initially, Stratton dug a half-pipe out of the earth near the top of the old Tyrolean lift. In addition to being out of the public's eye, the method was problematic, as there no way to build a snow base. "There's still dirt at the bottom," Paul Johnston remarked. "It didn't make any difference how deep I went....Come spring, when everything melted, you still needed good solid three–four feet of base."[23] After the failure of the dug approach, Johnston also piled hay bales on the side to avoid needing lots of snow.[24]

Finally, Stratton blew massive piles of snow and then sent in manual labor to shape out the pipe. Johnston put rider Beau Thebault in charge of the hand shaping. "They were like 'OK, so here are some rakes and hoes.... Go shave out the transition." Thebault entered the pipe and immediately concluded that "there's no way that's going to happen." The ice was simply too hard to break through, and Thebault had inadequate tools. Thebault approached John Thouborron and said, "This isn't going work....There's no transition here." "And somewhere that afternoon P.J. came to me and said, 'What do you need?' I said we need some kind of a backhoe to actually dig a transition out of this. He found me a few hours later and said, 'Can you be here at seven o'clock tomorrow morning?'"[25]

Johnston contacted local contractor David Chaves, who "was nice enough to let Lyle Blaisdell come up."[26] Blaisdell entered the pipe and used the excavator to shape the pipe. "I don't know if anybody can actually dispute this," Jason Ford remarked,

> but Beau Thebault and I were the first people to ever drop into the Stratton pipe. I remember coming down and seeing PJ stand at the bottom and he didn't have his little chew stain yet, because he was infamous for staying in

The earliest half-pipes were built in the dirt during the summer. *Hubert Schriebl.*

the same spot and having the biggest chew stain in the snow, and he goes "What do you think?" We were like "This looks incredible." He goes, "Go ahead." He let Beau and I ride it by ourselves that afternoon....We didn't know what the hell are doing, we were just trying to keep it together.[27]

Blaisdell was more or less on retainer for Stratton. He came up every few weeks, unloaded the excavator and cut the pipe. Seth Miller remembered seeing Johnston in the snow cat "and Lyle would be in the excavator and they would just work together like harmony. They had quite the routine going down. He would cut it and Paul would come down and pull the stuff out. It's pretty cool how they did it. It was way ahead of the time. He was an amazingly skilled operator to do that. To operate an excavator on ice in the middle winter is pretty good."[28] Johnston continued, "I would follow Lyle with a grooming machine, and we would go down and do one side and he would go vertically with that grader bucket and go down to foot straight and then do the transition. His bucket had a perfect swing for it."[29]

Blaisdell was perfect addition to the Stratton U.S. Open mythology: a Vermonter working for a local contractor who was an artist with his heavy machinery and perhaps one of the most famous recognized backhoe operators in the 1990s. Trevor Graves felt that Blaisdell was

Seeing that digging pipes out of the dirt was futile, Paul Johnston hired local excavator operator Lyle Blaisdell to carve the half-pipe out of mounds of snow. *Neil Korn.*

> *the God of building half-pipes at the time....He was just a mechanic...*
> *just a good old boy, pretty quiet. The whole culture knew him and revered*
> *him because he would basically know how to use that front loader or*
> *the backhoe and be able to dump the blade to shave out a nice eight-foot*
> *transition consistently. And so that's where Stratton got the advantage and*
> *really helped the progression of snowboarding, through Lyle's use of the*
> *backhoe and loader.*[30]

Lyle Blaisdell and his expertise with the backhoe was legendary within the snowboarding world. *Trevor Graves.*

A common thread in this overall story is perpetual improvisation. There were no preset rules, written directions or blueprints. There was a spirit of creativity and trial and error that epitomized the early days from judging techniques, high back bindings and half-pipe making. Ryan Foley felt that innovators like Sims, Carpenter and Barfoot handed a lump of coal to the first generation, who "start[ed] chipping this thing away and crafting it into the diamond of the winter sports industry that it is today."[31] Ian Price added, "It was completely unscripted…no plan at all. No one ever had the vision of the sport getting to the level that it's at now."[32]

Blaisdell was no exception to this innovative spirit. He discovered that the bucket claws were a hindrance to perfect pipe making. Graves continued, "He took a piece of one-inch steel and made it flat so that it would be smooth. And that was the secret ingredient. You see it from the bottom, you see this guy dumping a bucket, but in reality, he adapted that bucket in order to get that smooth transition."[33]

While many ski areas in New England had a half-pipe, none compared to the one at Stratton. Seth Miller first learned to snowboard poaching at Mad River Glen but eventually moved south to Stratton as "the half-pipe was always the best place in the east. It was the biggest pipe and the way it was cut with the excavator and the efforts the mountain put in for contests was way ahead of its time. It became the Mecca for snowboarding on the East Coast."[34] Jason Goldsmith was at Stratton in 1988 and remembered looking over and seeing that "they were building something. You could see it from the gondola and I was 'what are they building over there?' It was all these piles of snow. They had a cat running up through the middle."[35] Seth Neary, who came down from Sugarbush knew that the Stratton half-pipe was the best in the world at that time. Neary attributes the quality pipe to

Paul Johnston. "It really felt really cool to have the boss of the mountain dictating when it was going to be cut, how it was going to be cut…whereas other mountains, they cut it once and that was it."[36] Jason Ford shared the same sentiment as Johnston's "passion for that pipe—his approach and his enthusiasm for us as riders was incredible."[37]

Every now and then, the mountain closed the half-pipe for routine maintenance, most often before big events. This was the equivalent of a Zamboni run on an ice rink, but in reality, it was more like fresh tracks. "There was a whole crew of us that would [be] foaming at the mouth for him to finish the pipe," Seth Neary recalled. "It was like who could get into their binding first, who could strap in first and drop in on this fresh corduroy half-pipe, which was unheard of anywhere else. And Paul Johnston would be on the deck and he would see the stoke on our faces and we would be thanking him so much, so much gratitude to that guy because he really had the vision."[38] While Blaisdell was working on the pipe, Ross Powers took runs, and "we would lap around, we would wait, we lap around, we would wait and when it finally opened, it would be an amazing session of everyone. Back then everyone hiked the half-pipe and cheered each other on…it was awesome."[39]

Dave "Hooter" Van Houten was the Stratton Parks manager from 1993 to 2004. In addition to pipe maintenance, Hooter's responsibilities included "checking tickets to keep the kids from Connecticut coming up to hike." The enforcement

> was a weird situation, a fine line for me to walk, because Joyce [head ticket checker] would come up and make sure everyone…had a ticket. So, if I was like "Yeah, yeah…I know you're Seth Neary or whoever with a photographer" then I would see her start to come up. I was like "You guys got to &&%^ beat it. Go to the marketing department." And then I started to get the reputation of being the pipe Nazi. And then I talked PJ into having ten-dollar hiking pass.[40]

Looking back, Hooter felt those days were "the coolest *&^% thing ever, after being at Stratton that many years." Working with Paul Johnston and Skye Foulkes seemed "like the last days of the Wild West when it comes to a ski area. They didn't give a *&§%. They did what they did. Make it look good to the clients and just get the job done." According to Hooter, Johnston "was like a kid in sandbox." He always had a Red Man chew in his cheek, laughing about and showing an incredible enthusiasm for the task at hand.[41]

Before the Stratton Club was built near the gondola, there used to be private homes in the vicinity. In the early days, you had to have a pass to hike the pipe, which simply did not fly with a lot of snowboarders. As a result, many parked nearby and walked over. "I would say 75 percent of the people did not have a pass so they were hiking," When the ticket checkers entered the pipe, they walked up one side of the pipe, and as soon as Seth Neary and his cohorts "saw them coming, you would just drop in and go to the other side of the pipe and just hang out. They weren't going to chase you."[42] Jason Goldsmith described a typical interaction:

> We would be hiking up and Paul Johnston was sitting on the wall saying "Hey guys, how are you doing?" [We responded] "We're great. Great." And he's like "We have almost got it done for you." And we were like "Sweet." And then he goes "Do you have a pass?" We were like "Yeah, yeah. I left my jacket down at the bottom." He was "No, no that's ok." That happened a lot.[43]

Alexie Garick was a law-abiding half-piper, buying season passes. Despite the fact he had the whole mountain at his disposal, the half-pipe beckoned him all winter long. "It was mainly the half-pipe. You would take runs to break it up," Garick recalled, "I was there for half-pipe. The freeriding was something you did because you're at the top of the mountain anyways."[44] "You never got on the lift," Kris Swierz recalled, "We wouldn't even walk past the lift....We walked through a side trail and you were pretty much right at the pipe. I think only once or twice did I ever see anyone ever come check for tickets. They kind of caught on after a while. They didn't patrol it too hard."[45]

Ross Powers remembered hiking the pipe with people like Neary and Swierz. "They used to mess with me once in a while," recalled Powers. One afternoon, while hiking up the pipe as "a little kid at the time," the elder boarders "let my board go, so I had to go all the way to the bottom, get my board back, hike back. Just as a joke, but they like to say, 'you remember that'—it made you stronger."[46] While Neary was having fun, he "definitely recognized a younger generation coming up that were going to take it to the next level, and sure as shit they did."[47] Riders like Powers, Danny Kass and John Smallwood, who were all five to ten years younger than people like Neary, Goldsmith, Miller and Swierz, "were amazing riders." Neary continued, "They were a lot younger than we were. We knew that they were the next generation. They were there

trying to learn all the tricks that we were doing. And they were learning those tricks."[48]

While a beacon for pipe riders throughout New England, the Stratton half-pipe was not full-time Elysian Fields. It would have its good days, and it would have its bad days. When Jason Goldsmith had a "fresh pipe, it was fun." He continued, "When it was beat, it could be rough times....Most times it would be good but we never knew what the weather was going to throw at you....Sometimes we would actually luck out. They would say, 'They cut it earlier this week....You guys have a fairly good fresh pipe."[49]

When April arrived and the lifts closed, the half-pipe often kept on rolling. The local snowboarding contingent came up to "session that pipe until well into the spring after the mountain had pretty much dried up. The pipe walls were there, there would be one hitters and you had to build paths from wall to wall. I remember going up there every day for a week in the spring, riding and it was frickin' awesome."[50] Eventually, this tradition became more formalized with the creation of the EQX Games. Sponsored by a local radio station, the event featured snowboarding and skateboarding and provided a blend of seasonal sports.

While Stratton is at the epicenter of this tale, Magic Mountain and Bromley were also becoming snowboarding hot spots at this time. There was the "Glebelands" crew—named after Mount Glebe, the mountain that comprises Magic Mountain. It consisted of Shem Roose, Randy Gaetano, Gavin McMorrow, Scott Lenhardt, Jesse Loomis and the LaVecchia brothers, Nick, Vince and Mike. They rode a lot at Magic and eventually called Bromley their home mountain. For Shem Roose, who had no skiing background, Magic Mountain was his first ski area experience. Up to that point, he had only been snowboarding near his family farm in Cambridge, New York. On his first run, his skier friend brought him to the top of the mountain, forcing a trial-by-error experience for Roose's first foray on packed snow. Despite an inauspicious beginning, Roose had "such great memories from riding Magic and Bromley with all those guys even when conditions were absolutely crappy. I can remember some of our best days were riding in the rain because we were we were all so stoked to be hanging out and riding together."[51]

Ross Powers spent his first years at Bromley following Kurt Meyer and other instructors around the mountain, keeping up with elder riders. Manchester resident Ian Price spent a lot of time at Bromley. Like Powers, his mom worked at the mountain as a ski patroller. Price and Powers spent a lot of time riding together. On the day of his certification, Price was nervous,

thinking to himself, "Am I going to pass? Am I good enough? I have only been doing this for a week."[52] About an hour before his test, Kurt Meyer approached Price and said, "You're all good. Don't even bother. Here's your certification." Meyer had been observing Price riding with Powers, and "instead of guilty by association, I got certified by association."[53]

In the early 1990s, Burton often held a preseason camps at the Magic Mountain half-pipe, so riders from the area poached the pipe. The real attraction at Magic, however, was a railing that led from the parking lots to the main lodge. The pedestrian railing was "super long, twisty, not very steep but just really long and twisty."[54] Jason Ford recalled, "And when the jibbing era came on, it was all about who could conquer the Magic rail. And I don't think anybody ever got it."[55] Brew Moscarello had a cathartic experience while snowboarding at Magic. On a powder day, he, J.G. Gerndt and Craig Kelly rode a long, flat trail at the top of the mountain:

> *I wasn't nearly as good as these guys. Craig is hitting everything you could possibly hit. And there is JG right on his tail. And these guys were making something out of nothing. The light went on. "That's what snowboarding is!" And I rode with those guys, and it just took me to a whole another level. That one day. To this day, that is my riding [style]…make it happen!*[56]

As Stratton figured out how to make the perfect pipe, the riders were simultaneously identifying the needs for the board itself. Just as alpine racers developed homemade high back bindings in the 1980s, the half-pipe riders adjusted their boards. "We were taking albums and cutting our noses off of our board and our tails. We were changing the way the industry was producing the equipment." Seth Neary recalled. The sponsors delivered boards with a lot of swing weight, making tricks harder to execute. Neary added, "Who in their right mind would take a $400–$500 board and hack the nose and tail off.…But it was functional. And it worked. And then the next season, you saw the manufacturers making the same boards that we were cutting out."[57] According to Ryan Foley, they lived in "unprecedented times, and it's just super rare in life to have a chance to be a part of something like that. More so, not even having a clue as to what we were doing, how we are doing it, who is allowing us to do it and where we'll do it. We just didn't care, we just did it."[58]

BURTON CORPORATION

BURTON EXPANDS FROM A BARN OPERATION TO GLOBAL LEADER

STRATEGY WAS HIS STRENGTH

The late 1970s saw Carpenter peddling his boards to ski shops out of his truck. Carpenter recalled that he "would go out in the car, load up the car with boards and drive out across New York State, trying to sell them door-to-door to shops."[1] In one instance, Carpenter returned from one of his trips with more boards, as one store returned the unsaleable merchandise.[2] By the early 1980s, Burton employed a small staff, produced a glossy catalogue featuring hard goods and soft goods and produced their first snowboard movie, *Winter Waves*. The tale of Burton snowboards can easily be labeled as a meteoric rise, and certainly looking at it over the decades, there was a huge spike. When examining the timeline more closely, there were years of commercial struggle, and a sales spike was not so evident. According to author Peter Heine, Carpenter claimed that his "first moment" was "when a teenage boy from California called on the toll-free number at 2 a.m. to order a board. Burton snowboards had made it from the East to the West Coast."

While the balance of power shifted to Vermont, Carpenter and his wife, Donna, moved to Innsbruck, Austria, in 1985 to learn about ski construction. As a touch of alpine karma, Carpenter's former boss at the Birkenhaus, Emo Henrich, returned to his hometown of Innsbruck in 1986. For a second time, the two people who were absolutely essential in shaping Stratton Mountain's identity shared a tangible bond. The two were directly or indirectly responsible for dictating everything from

snow sports education to fashion to après ski behavior. While very few equated doing the Chicken Dance in Obermeyer sweaters to the Stratton Mountain Boys with witnessing pole dancers in the corner of the Green Door Pub as cultural equivalents, however, Henrich and Carpenter are the roots of both cultural phenomena.

Jake and Donna visited several European factories to find snowboard manufacturers, and according to Donna, the Europeans responded with a definitive "'No,' until the last one, in a small town in Austria....They woke him up at midnight. His daughter had to translate. He said, 'Yeah, I'll make it.'"[3] Chris Copley praised Donna Carpenter, who does "not get the credit for what she did to build the company." She convinced Carpenter to take language classes at Middlebury College so they could negotiate overseas. "Jake went to the factories, and Donna was negotiating international distribution contracts." Copley added, "She is smart. All the back-end business stuff Donna was doing, but Jake obviously gets all the credit because his name is on it. Donna Carpenter did a lot of the heavy lifting."[4]

In 1989, Burton introduced a board with metal edges, clearing the way for hard-pack riding. That season, approximately 450 ski resorts allowed snowboarding. Stratton Mountain reported between ten and twenty thousand rider days during the previous season. Paul Johnston commented on Jake: "The one person that knew where he wanted to get to, and I didn't realize that for years, was Jake. He knew where he wanted to [go], he just didn't know how he was going to get there."[5]

ZIPPY (UPSTAIRS)

Eventually, the Manchester Burton factory moved up the road to an industrial park, symbolizing a transformation from home-based business to a larger operation with manufacturing and retail on the first floor and business offices on the second floor. The office nomenclature evolved to where they had "downstairs" and "upstairs" work, but in the end, "everyone was pretty much in love with snowboarding."[6] If employees' did not know anything about snowboarding prior to being hired, Carpenter's infectious enthusiasm was to change their indifference in due time.

Dave Schmidt was fresh out of Syracuse University and working for the Ski Market in the Albany area. In 1986, he responded to a classified ad for an account executive position. After two interviews, Schmidt took "one of the

Reflecting the rapid growth of the sport, Burton Snowboards moved from Carpenter's Manchester barn into an industrial park up the road. *Burton Corporation.*

lowest paying jobs I've ever had at the time....I actually took a pay cut from working at a ski shop to move to Vermont."[7] Champlain College graduate Scott Richmond was an intern at Orvis in 1985. After Orvis "offered me a huge increase of five cents an hour to stay with them," Richmond answered an ad for a computer networking position at Burton. Richmond oversaw a small network of PC-driven computers that managed the sales, accounting and inventory. The company was still fairly small in staffing. There were weekly Friday meetings in a room that held ten to fifteen people, but "that meeting got to a point where we had to stop having it because it got too big and too onerous."[8] It seemed that the critical mass of the company was in the forty to fifty range in the late 1980s.

After attending Southern Vermont College, Carol Plante slowly moved northward to Manchester, working at Bromley and then arriving at Burton in 1986 as a customer service representative. She was one of eleven employees at the time. Initially, she worked under Mariana Fruhmann, champion of the 1982 championships, and then Plante took over the manager position.

In the early 1980s, Brew Moscarello worked at an Eastern Mountain Sports in New York. After calling Burton to order boards, he was

encouraged to interview. When Moscarello called, "They were all excited because they thought I was a buyer and buying a whole bunch of boards. They were hurting for selling boards, and I'm like 'No, I'm just the retail kid…fresh out of college.'"[9] Interviewing in early March, Moscarello received a trial by fire. Burton said "Come back next week. Work the U.S. Open, see if you get along with everybody. And if so, we'll talk then."[10] After Moscarello passed the "test," Burton gave him another trial and said, "'We'd like to hire you but you have to get in the truck in two days and drive the truck to Vegas to the SIA show.' I was a kid in a candy store, I was psyched. I went back to Yonkers, packed my stuff, came back, got in the truck and drove out there."[11] Moscarello was put in charge of the southern East Coast, initially a challenge, especially at the beach side surf shops in August. He "didn't even realize that I was there to like take orders. I thought I was there more or less there to what I could do to represent. I came back and Jake said to me 'How many did you sell?' I was like 'Dude, it's summertime, I am on the beach.'"[12]

Arriving in 1989, Chris Copley was the jack of trades, as he "started basically doing everything from making boards.…They needed some help in accounting…[so he] helped do some filing. Then they said 'Hey, we need some help promoting the sport here.' There was not a marketing department. There was one woman who was the marketing director at the time, and she had no staff."[13] The woman was Ellen Holmes, who spent her career running the magazine *Psychology Today* and retired to Manchester. Having never snowboarded, Holmes "was this nerdy little old woman but super smart, and she walked into Burton and said, 'Jake, your marketing is horrible. Your ads are junk. Your catalogue is so amateur.'"[14]

Fresh out of Arizona State University, Jon Yousko answered a wanted ad in Burton's dealer newsletter, *Fast Tracks*. Yousko initially interviewed with Paul Alden in Denver, and after surviving the first rounds, he was one of three finalists to fly to Vermont. Yousko believed that it was "a dream come true. Kind of being at the right place at the right time." After his interview, he was downstairs about to depart when Leonard Augie said that Jake wanted to talk. "I got to sit down with Jake for a couple of hours. That was super cool. I was like 'OK, if I don't get a job, I had a chance to rap with Jake for a while,' and I hit it off with Jake. I think that's what did it." The ensuing conversation was symbolic of the sea change that was happening within Burton. "At the time, Burton was a real Alpine-dominated brand, very East Coast influenced," Yousko recalled. For the next hour and half, "all we talked about was surfing. He was really intrigued

with my skateboard background. So, we talked a lot about skating and how I thought skateboarding was going to influence snowboarding." Yousko even told Carpenter that he rode a Sims board and that on the West Coast, "people joked about Burton" and its race image.[15]

Over time, Holmes, Copley, Yousko and Carpenter worked together to change the Burton brand. They picked Craig Kelly, Jeff Brushie, Keith Wallace, Mike Jacoby and Tara Eberhard to be the new faces of Burton. If there ever was an administrative move that ushered in the demise of alpine boarding, this may have been it. Andy Coghlan, Mark Heingartner and the Hayes brothers were disappearing from the catalogues and photo shoots, and the Burton Five started showing up in the ad campaigns. Yousko felt that "Burton saw that's what the market wanted."[16] He told Carpenter that "'alpine is cool and all, but it ain't happening.' People want to ride half-pipes, they want to ride powder and bomb off jumps. Burton slowly morphed into that."[17] The culture also changed within the company. For years, Burton employees arrived at the Vegas sports shows and wore coats and ties, reflecting the ski industry. Yousko recalled, "I still vividly remember…I'm like 'Why don't you let me wear one of these new Burton shirts that we're selling and let's see what happens.' I wore a pair of jeans and that was the end of it, right there."[18]

With Carpenter in and out of office, day-to-day operations often fell on the shoulders of Leonard Augie or Paul Sundman. When the Carpenters moved to Austria, he was essentially "running a European operation and an American operation," which was "incredibly stressful and sort of ragtag."[19] In general, Jake did not micro-manage his employees. Dave Schmidt felt that "one of the things that I loved about working in Burton…was the fact that we were left to do our jobs.…Jake was certainly not a 'an over the shoulder' type of manager. He let people do their own thing."[20] Carol Plante added that Carpenter "had very high standards and he was incredibly driven. He trusted people to do their jobs."[21] When it came to distribution, Carpenter trusted many of the decisions made by Schmidt. "There was a lot of cleanup… when I got there," recalled Schmidt. "The product was in a lot of places it shouldn't be. We had to shut to a lot of the dealers down, and 90 percent of what I did as a sales manager was say 'no.' It was the hottest product on the market in sporting goods—hottest brand in the category and everybody wanted it. We had to say no to most of the people calling us for products." Schmidt turned away big-time dealers such as Herman's Sporting Goods and Neiman Marcus. Schmidt continued, "It was critical for the brand to be in the right place. We saw the birth and growth of specialty snowboarding

retailers, and we cut back significantly on all the mail-order distribution at the time."[22] The closing of the mail-order business was perhaps the biggest point of contention between Carpenter and Schmidt. Mail order was the early bread and butter for Burton. By placing ads in magazines such as *Thrasher*, *Action Now*, *Powder* and *Snowboarder*, Carpenter was able to get the company off the ground. "The only way I was going to be able to grow the wholesale distribution was to get out of the mail-order business." Schmidt continued, "It was a very testy topic with retailers when I didn't have product for them, but we were still selling it in our mail order."[23]

The Burton corporate culture at this time was "full throttle, hundred percent," remembered Chris Copley. "I wouldn't say we were competitive with each other. It was like who could outwork each other, like who can work harder…because you were so stoked."[24] There was always an element of uncertainty. Copley remembered that "a lot of the people were boot strappers…they learned on the job."[25] Carol Plante recalled that the factory "was completely crazy because the growth at that time was like three to four hundred percent a year and it was really busy all the time."[26] It was a hectic space with long working hours, forcing many to resort to coffee to keep them going. "We would drink coffee until we started to shake," recalled Plante. "We got all fired up, and it was kind of a joke—who had the biggest coffee mug."[27] Plante added that the Burton employees "fed off of Jake's enthusiasm for the sport.…We really pushed ourselves to do the best we could do and to really propel the sport forward."[28] Moscarello felt that Carpenter "was very enthusiastic about what he was doing. To his credit, he always looked at it as a business too. He had his emotions but he was able to focus."[29] The work environment was "demanding, creative, almost no rules, a lot of outside the box thinking," Thouborron, who joined Burton in 1985 as employee No. thirty-two, felt that there was an "invitation to make mistakes.… There was some long nights. I remember pulling all-nighters with Jake, leaving at 7 o'clock in the morning to go home take a shower and be back at 8."[30] According to Scott Richmond, "The whole industry was changing so quickly and everything about it—the technology, the boards, the people, the riding styles. Everything was just so quick."[31] Thouborron continued, "Jake's passion trickled down to everybody that was there. He is pretty demanding. He expected each and every product to be improved every year. It wasn't just improving the product every year but improving the service."[32] Scott Richmond added that the Burton "crowd was very young, so the people coming in were young, they were smart, they had

really good ideas and he listened to those kinds of people. And would take their ideas and really let them prove themselves."[33]

At some point, there was a "Black Friday" at Burton, and many original employees were let go. As Burton continued to grow exponentially, the company needed "the cleanse and was probably a necessary evolution of Burton."[34] There were people who were abusing the system by taking too many breaks, but the event that may have set Carpenter on a rampage was when an employee or employees must have messed up a run of boards and tried to hide them without reporting the error. "There was a lot of people let go and then the people that let the people go, got let go. That was a rough day," recalled Scott Richmond. This was a major blow to many people "There was a lot of people pissed. There were a lot of people taking duct tape to their equipment...all that anger," recalled Jason Ford, "But I also know that those guys would constantly *&^% around,...The company has grown up...and it just had to mature."[35] John Thouborron didn't "remember it being referred to as Black Friday because there were several of them. I remember the first one. And I think that there was an element of one pretty much every year for the next successive years."[36] Richmond felt that one really had to mess up to push Carpenter's buttons: "He was a pretty easy-going guy. If you worked, you put forth effort and you showed him that you were into what you were doing, he had no issues there."[37]

ZIPPY (DOWNSTAIRS)

It seemed that Carpenter was much more comfortable downstairs. When it came to product, Carpenter was the "decision maker." Dave Schmidt added, "No product got released, no graphic got released, no color got released without Jake's blessing."[38]

Moscarello eventually ceased being a full-time sales representative. He proceeded to teach snowboarding in the winter and work at Burton during the summer months. He was living with his girlfriend and Dave Schmidt on Richville Road when they got a fourth roommate, John "J.G." Gerndt. Gerndt "grew up skateboarding and surfing some, but I knew that I wanted to surf mountains of snow when I was twelve."[39] He started off as a Burton team rider, then transitioned into product development. Like so many other employees, he tackled everything "from production and retail to warranty and quality control." He eventually transitioned to product development,

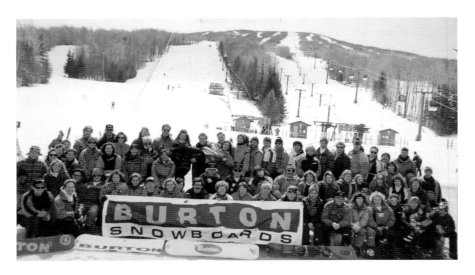

Wanting his employees to fully embrace the sport, Jake Carpenter often brought the entire company to the mountain for free lessons. *Brew Moscarello.*

overseeing every piece of hardware that passed through Burton's halls there on out. Gerndt's work brought him out on the snow more than any other employee. He traveled with the team riders and tuned their boards and customized their gear, "having them test product and give him direct feedback."[40] In a similar fashion, Scott Richmond's job description evolved from network techie to prototype tester. Paul Wren often traveled with the team, getting feedback from riders. The data returned to Manchester, they built a prototype and "handed it to me Friday night, said 'ride this weekend, let us know how you like it on Monday.'"[41] Andy Maravetz was working for engineering firm in New Jersey when he called a friend of a friend, Burton's Andy Laats. Yearning to combine his passion of snowboarding with his degree in engineering, Maravetz interviewed with Laats, whom Maravetz expected to be "some thirty-year-old dude. It turned out the Burton office/ factory in Manchester was this cool post and beam building with a mellow work environment and Andy was a long haired twenty-four-year-old who ended up offering me a job."[42]

Young team riders often worked in the factory. Team rider Todd Davidson conducted his high school senior project at the factory, serving as the international sales analyst, "counting the number of boards sold by country in Europe and it was like 12…9 [boards]. It was absurd."[43] Mike Hayes worked at the factory assisting with warranties, repairing bindings

that would rip out. Hayes continued, "So I would have to drill through and put in an insert—basic factory work."[44] Steve Hayes eventually joined his brother, and they "were grinding fins and stuffing boots—putting ski boot bladders into sorrel type boots." Since they were sponsored by Burton, the Hayes brothers had free rein of the factory showroom. "We would go in there and just fill our pockets with all the team stuff," Steve Hayes said with a bit of nostalgic glee. "We would load up with all the outerwear, soft goods, hard goods, couple of boots, couple of decks, couple of pair of bindings, couple of different outfits and that was cool, like going shopping."[45]

The factory was no less hectic than the chaos upstairs. One year, panic ran through the entire building. When Burton adopted high back bindings and new foam boards, Dave Schmidt recalled that "nobody factored…the additional leverage that the high back would be putting on the board." The result was a near disaster as "every insert in the board came out." The factory went into overdrive and repaired every single board. Moscarello was downstairs "on the drill press, boring out the old ones, putting new ones in." There was no end in sight, as the boards "just kept coming."[46] Schmidt added, "a lesser company would have gone bankrupt….It was a pretty stressful situation when dealers were calling left and right and customers were unhappy, but we did we get manage somehow to pull it off."[47] Moscarello felt that incident could have been "detrimental" but "the passion is what really kept it going. It was people's love of the sport."[48]

An early Achilles heel for Burton was staying on schedule. They could not produce boards fast enough to meet the demand. Carol Plante recalled that "getting orders shipped out and making sure that everything was right and doing as much as we could to make it happen, it was stressful."[49] Come December, with the phone ringing off the hook from impatient dealers, Burton was often in crunch mode. The entire staff dropped everything and worked 24/7 to get the boards out the door. Plante went downstairs, and the production manager gave orders—"whatever was going to be helpful… putting pieces together, laying them out…or we would help out shipping. And we did that more than once."[50] One year, Dave Schmidt recalled, he returned to his office after a cram session and encountered "a stack of 'we'll call you back' pink slips that was, when rolled up, about three inches in diameter." Schmidt "rolled them up, put a rubber band around them and tossed them in the trash…because they all had the same question. They just wanted to know where their boards were."[51]

Another year, as December rolled around, the company still had plenty of boards to ship. In lieu of a shipping service, Burton rented two trucks, and

Jake and Dave Schmidt drove all over the Northeast delivering boards. It was almost as if Jake had stepped into a time machine, driving to ski shops and selling boards out of his truck, just as he did in the early 1980s. One year, a whole shipment of boards from Austria was stuck in customs in Canada. A crew of five went northward in a Burton van to get the boards released. The negotiations took several days. "So, when we go to Montreal, what do you do? You go St. Catherine Street drinking all night and then you're hung over in the airport all the next day with jet fuel and the stench of the forklifts."[52]

One of the early challenges turned into the company's biggest success. With Craig Kelly caught in a contract battle between Sims and Burton, he competed in the U.S. Open with the legendary black, non-logo, Mystery Air. "We had to build them so quickly that their production couldn't handle it," Scott Richmond recalled, "We went on a twenty-four-hour schedule where everybody in the building took a turn at building boards."[53] Burton did not have a deal signed by the time of the important trade shows. The company improvised and placed a crate marked "Mystery Air" in the trade show booth. The end result was "one of the most successful marketing plays we ever did…just by putting the crate in the trade show booth. There was a huge response to it, and that board lived on."[54]

NOT YOUR DADDY'S CORPORATE RETREAT

It wasn't all nose to the grindstone, as Carpenter often held employee parties. In the late 1980s, Todd Davidson showed up with a "handful of riders because they're really weren't that many back then." Davidson recalled one Christmas party where "Jake came to the party, and he was… so elated that all the people were there and it was a big fun event in the warehouse…a really, really low-key event."[55] Scott Richmond felt that Carpenter "was a cool guy to work for," as on "late Thursday afternoons," Carpenter often hosted a barbecue, and the factory migrated down the road "to his house and play touch football in the backyard, have a few beers, listen to music, play Frisbee, have some food and then go home. It was a really good environment."[56] Jon Yousko remembered that every Thursday after work, "everyone from the company would come out to play. We had a keg out there. Everyone was having a good time."[57]

The Carpenters also hosted the annual Fall Bash. Held at their house, the October pig roast was half company picnic/half pre-season pep rally.

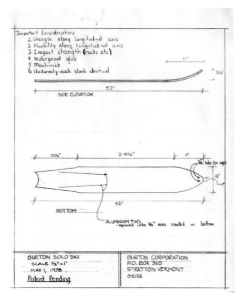

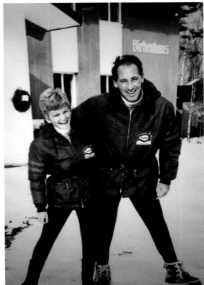

Left: Board drawing, 1978. *Burton Corporation*.

Right: The Heinrichs in front of the Birkenhaus. *Stratton Foundation*.

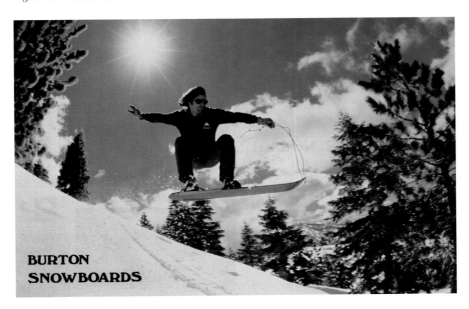

Burton catalogue, 1981. *Burton Corporation*.

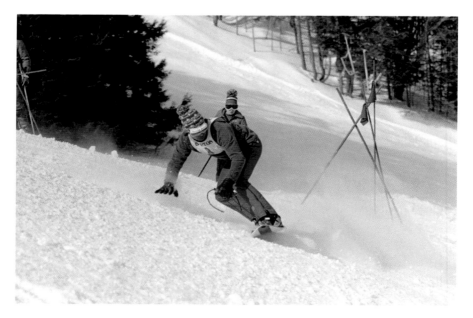

Using a rope at the 1982 Woodstock races. *Richard Howard.*

Jake Carpenter and some early press coverage at the 1983 competition. *Burton Corporation.*

Left: 1990 U.S. Open poster. *Right*: 1994 U.S. Open Poster. *Burton Corporation.*

1988 U.S. Open poster. *Burton Corporation.*

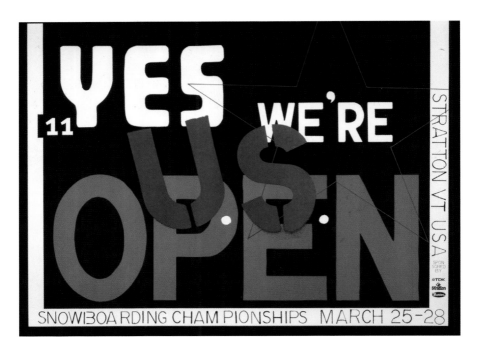

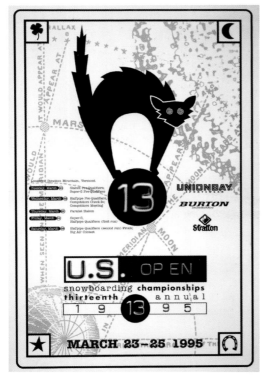

Above: 1993 U.S. Open poster. *Burton Corporation.*

Left: 1995 U.S. Open poster. *Burton Corporation.*

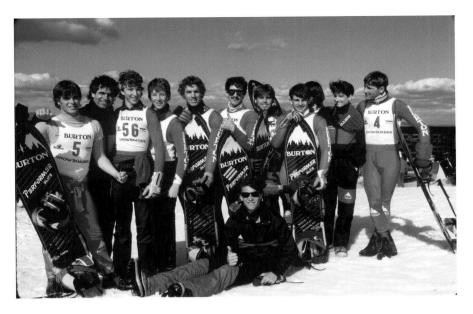

Above: The 1985 team. *Hubert Schriebl.*

Left, middle: Hiking the course at the 1983 competition. *Hubert Schriebl.*

Left, bottom: Jake Burton Carpenter was well known for his competitive nature—on the slopes, in the business world and on the flag football field. *Burton Corporation.*

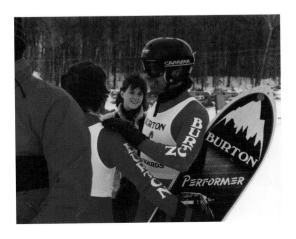

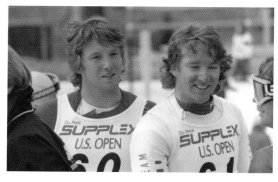

Mike (*left*) and Steve Hayes.
Michael Devito.

The Heingartner brothers. *Hubert Schriebl*.

MC Chris Copley and Rider Jeff Brushie. *Neil Korn*.

Seth Neary (*left*) and Seth Miller.
Tricia Byrnes.

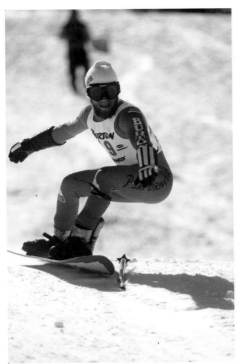

Left: John "JG" Gerndt, racer, product tester. *Hubert Schriebl.*

Right: Ross Powers. *Jamie Schriebl.*

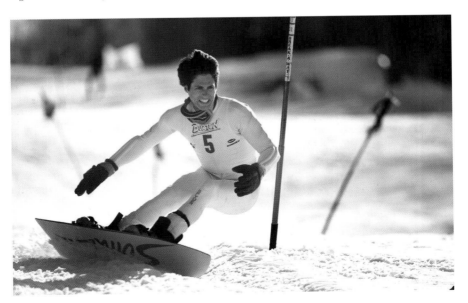

Craig Kelly in the gates and on a Sims board. *Hubert Schriebl.*

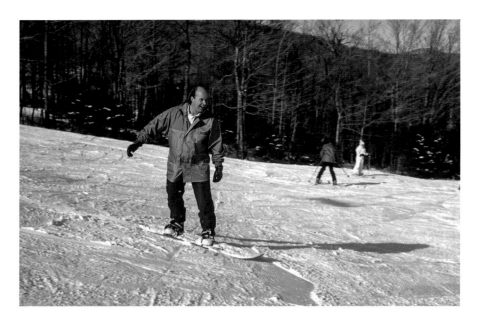

Paul Johnston. *Hubert Schriebl*.

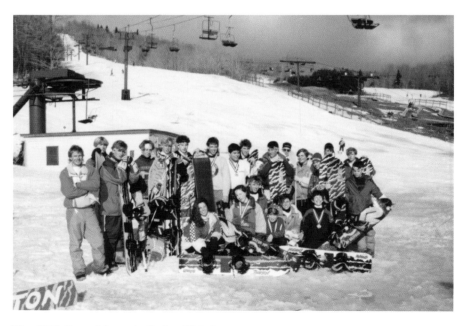

The 1988 Green Mountain Series. *Tricia Byrnes*.

Picture of the VTSP crew hanging in the Hayes family basement, circa 2017. *Brian Knight.*

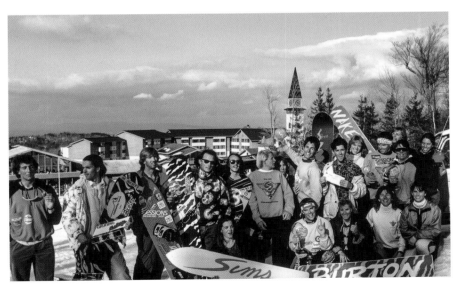

Riders in the early U.S. Opens vied for top honors as well as a Samurai car from the Suzuki sponsors. *Hubert Schriebl.*

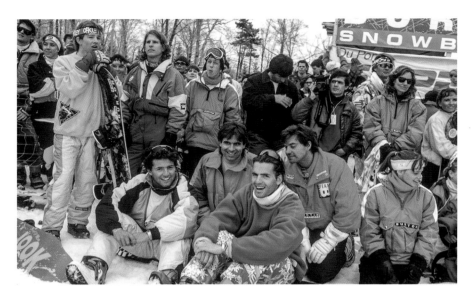

Jake Carpenter and Peter Bauer and a sea of pastel at the bottom of the halfpipe. *Hubert Schriebl*.

Tricia Byrnes getting her medal on her home turf in 1992. *Tricia Byrnes*.

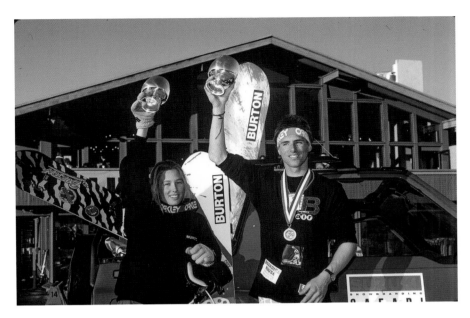

Winners Craig Kelly and Tara Eberhard. *Hubert Schriebl.*

After a horrible snowboarding accident, Steve Hayes (recuperating on couch) stopped competing and started Hayes Brothers Snowboards with brother Mike. *Brian Knight.*

Right: Lyle Blaisdell at work. *Neil Korn*.

Below: Participants of the Jeff Brushie camp at Bromley Mountain. *Neil Korn*.

Locals Corner at the Green Door Pub. *Brian Knight.*

Ross Powers winning in
1999. *From the Vermont Review.*

Father-son photographing team, Hubert and Jamie Schriebl. *Brian Knight.*

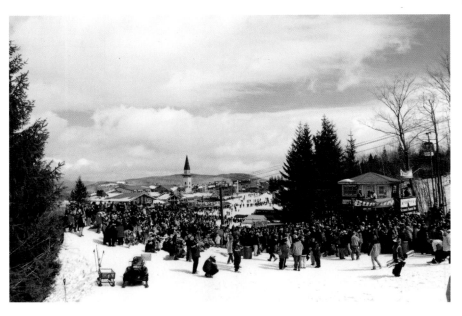

Revelers and spectators at the halfpipe, 1998. *Brian Knight.*

Above: Mike Hayes in the legendary basement, 2017. *Brian Knight.*

Left: Chris Mollelo (*left*) and Steve Hall, circa 1987. *Burton Corporation.*

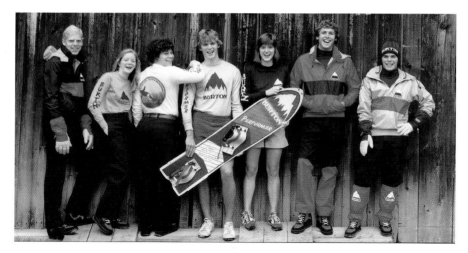

Above: A 1984 catalogue. *Burton Corporation*.

Right: Andy Coghlan letting it go in the gates. *Hubert Schriebl*.

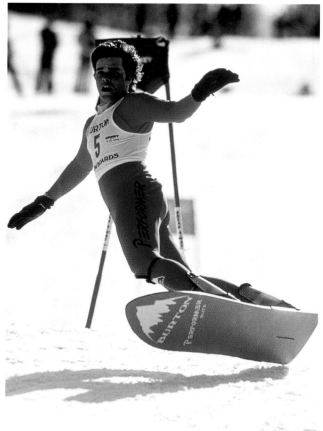

"Those parties were incredible," Chris Copley remembered, "People dancing...slam dancing...having punk bands playing in his living room...an incredible house where people were getting wasted and going nuts."[58] For a brief time, a band—the Cruel Germs—made up of production employees, played at the party on the Carpenter's porch. Emmett Manning added, "It was more of college frat party where you get seven or eight kegs. It was real big with a flag football field. Get going late in the afternoon with that and just kicked into a band and partying to all hours." The party was a small affair with a small tent, and it was "more family oriented than they were later. A larger portion of the attendees were relatives of Jake and Donna, some business associates and a few riders but not too many....Vermont riders would come. It just started getting bigger and bigger after that."[59] With Manning, Carpenter and few others being the only parents among the revelers, the parents took precautions during the Fall Bash. Manning took lawn furniture and made "a little playpen to keep them somewhat safe because they slept on blankets."[60] Jon Yousko added that the Fall Bash was "cool as shit. You showed up in the morning for football, and then it was people having a good time...one of the coolest parties of all time."[61]

While many came to Burton with a knowledge of snowboarding, some came in cold turkey. On Carol Plante's first day on the snow, a combination of East Coast ice and poor boot advice led to a broken ankle. After surgery, Plante returned to work "with a plate and screws in my ankle because we needed to be there to get the work done and it was a really a critical time."[62] Being an avid skier, John Thouborron did not snowboard until after joining Burton, when Jake gave him personal lessons. "Jake was definitely in it for the business. He wanted to be successful," remarked Scott Richmond.

He loved snowboarding. He was into it. We had employee picnics on the mountain at Stratton at the end of the season. He encouraged everybody to at least try it. "If you're going to work for me, this is our product, go out and try it." And you got paid to go get a lesson. You got a board, you got boots, you got everything outfitted. You went up Stratton, you got a lesson for free and you got paid to be there to try it. Just because he wanted everybody to share his passion.[63]

Richmond joined Burton in the summer of 1985 and had his first experience on a snowboard, taking lessons with Mark Heingartner and getting certified by Chris Molello, three months later. "I hated winter. I grew up in Rhode Island, Connecticut on boats and in the ocean,"

Richmond explained, "And then came up here and I really didn't care for winters at all until I got into snowboarding."[64] Within two years, Richmond went from not knowing what a snowboard was to testing new prototypes on a regular basis, and by 1987, he "was giving lessons, doing demo tours and riding with the team riders." With riding partners such as Coghlan and Heingartner, "you have people pushing you and you learn quick. It was the caliber of the people that I was riding that helped me to learn and get better really quick."[65]

HANG OUT

Besides being the manufacturing center, the Manchester retail store was a destination for many young riders. Before Neil Korn, editor of *Eastern Edge* magazine, claimed Bondville as his home, he was a weekend warrior, making the weekly commute from New Jersey. On Sundays, before his trip down the thruway, he regularly stopped by the factory. When he moved to Vermont, Korn spent weekends hanging out in the factory. "We never really bought anything….We just went down there. It's just the thing to do."[66] Jason Goldsmith often made the journey down to Manchester. "We'd go down, hang out and talk to Emmett in the show room. We would see different things, boards and stuff coming in and out of the production. It was kind of a laid-back place, but it was like being a kid in a candy store."[67] Ryan Foley always stopped by before returning home, and "There wasn't enough gold in China to purchase all the things that we wanted to buy in that room."[68]

Longtime mainstays Mike LaVecchia, Emmet Manning and J.G. Gerndt were always around when Ross Powers showed up. Powers would go down to the factory with his mom "and stay as long as she had time to let me check stuff out and chat. And then I would be out of there."[69] His mom also used to borrow boards "depending on what discipline of competition [we] were doing in the Green Mountain Series."[70] Jesse Loomis recounted, "It was pretty welcoming….There was all the cool stuff. It smelled like new gear. It was kind of an old timey feeling in there but it was all the new stuff, all the Safari gear…weird pastel pink colors."[71]

Emmett Manning first tried snowboarding while attending St. Michael's College with Keith "K.J." Heingartner. After graduation, he explored different career possibilities in Boston, but the Green Mountains held more appeal than Storrow Drive. He talked with Carpenter and first considered a coaching job, but with two young children, Manning felt that a position closer

to home was a better option. He took charge of Burton's retail operations in 1988. Manning recalled that the factory was "busting at the gills. It was shipping, it was warehouse, it was production, it was offices and we were just banging the walls."[72]

Manning slowly developed the retail shop into a mecca for riders making "the pilgrimage to the factory." Manning continued, "When we first started off, it was pretty small. There was definitely a little bit of time where it was definitely quiet…especially for the first couple of years and so we built it up and got things going a little bit."[73] As the sport grew, so did the factory as a destination. By Manning's second year in the shop, "It started to get that first little cult following of shop kids that were a posse…younger kids from 14 to 18 that started to make it the hang out.…We nurtured and kept on going with it."[74] For Shem Roose, the journey to the showroom was a trip:

> *I grew up in a small town just over the border from southern Vermont.…I remember driving to Manchester definitely felt like a pilgrimage. You know even though it was only thirty minutes away if that. It was just a different vibe. There's a lot more money in Manchester than where I grew up. Then walking into the showroom and getting to see and hold all these different boards and to see all the products in person, blew my mind.*[75]

Roose was a member of the posse known as the Glebelands crew. The pack teenagers rode all day at Bromley, then migrated down to the factory and played videos. "They hung out for a couple of hours and then cruised up from there."[76] Scott Lenhardt and Jesse Loomis, friends since age three, first snowboarded on hills in West Rupert. Claiming Bromley as their home mountain, they eventually teamed up with the rest of the Glebelands crew. In the early 1990s, Lenhardt received a camcorder as Christmas present, and the two went up to Bromley "filming each other a lot and then we would see these guys having their way down the trail. They were so good."[77] The camera served as the vital link for bringing the Bromley riders together. Lenhardt and Loomis "linked up with them and started filming everybody" and then headed down to the factory showroom to "watch the day's tape on the big screen at the Burton showroom."[78] Shem Roose recalled that they went to the showroom at Burton "and [would] hang out in the back little corner where they have the TV and the VCR and we would just put pop in the VHS and watch our footage from the day."[79] After accumulating hours of film, they used an "old school, projector big screen TV" and watched in "slow motion all of our amazing airs." Loomis continued, "It was a bunch

of us just sitting there drinking Sunkist watching ourselves.…We felt pretty big time."[80] Brew Moscarello felt that "they were making their own stuff and they were pioneering it in many ways."[81] Mike LaVecchia was the key to the whole process, as he was a cashier in the factory. "So, we were in. Mikey had a lot of clout at that store."[82]

While a modicum of civility was maintained, in the end, the Glebelanders were still teenagers. Randy Gaetano "was always pushing buttons. He thought it was fun to get a rise out of people so he would push Emmett's buttons and everybody kind of would, but Emmett wouldn't take too much crap from people."[83] Roose was definitely afraid of Emmett in the beginning and was quick to confirm that "Randy would definitely push everyone's buttons."[84] The adolescent outbursts made an impression, as many of the Glebelands crew used the store as the step toward working for Burton. Manning took a few of them as shop workers: "If they are going to be there, might as well pay them, they are hanging out there anyways. They knew their shit. They knew the gear. They loved the company. They were all about it. It was good to have them."[85] Shem Roose felt that Manning may have looked intimidating, "but once you get to know him and he gets to know you…we respected each other and he knew I wasn't just some punk kid."[86]

The Glebelanders all went on to work for Burton in some capacity. Roose, Loomis and Nick LaVecchia brought their photographic skills to Burton. After inauspicious beginnings at Bromley, which was "icy with sharp edges and a sore butt," Gaetano joined the Burton Team.[87] Scott Lenhardt designed graphics for over fifty Burton boards, including the Shannon Dunn and Ross Powers models. LaVecchia, McMorrow and Loomis all held various positions in the organization. Playing a diverse selection ranging from Neil Young to Black Sabbath to the Cars, Loomis and Lenhardt's band since eighth grade, Butt Pie, also played the Grizzlies for a few U.S. Open parties.

ENTREPRENEURS

The combination of Burton, the U.S. Open and one of the best half-pipes on the East Coast solidified the snowboarding culture in southwest Vermont. In time, many other snowboard related business enterprises sprouted up in the area.

In 1991, writer Neil Korn attended the U.S. Collegiate Nationals at Stratton Mountain. Soon thereafter, Neil started a new snowboarding magazine, *Eastern Edge*. Throughout the 1990s, Korn documented not only the U.S. Open but also the snowboarding scene up and down the East Coast. Between 1992 and 1998, *Eastern Edge* sponsored On Snow Demo Days parties, which became the best-known Stratton party outside the confines of the U.S. Open weekend.

While teaching snowboarding with Stratton's Allegro Program, Moscarello and his roommate, John "J.G." Gerndt, developed Vew-Do balance boards. He saw that "most people had no clue of what balance was required to ride a snowboard"[88] He broke out an old Bongo Board, and they started messing around with it. While Moscarello was a passive Bongo boarder, J.G. got on the board, "goes back and forth, and all of a sudden, he starts trying to do spins and tricks and flips, snowboard moves, grabs. At that moment, that's what inspired me to take the Bongo Board to the next level, just like Jake took the Snurfer to the next level."[89] For Moscarello, "the light bulb went off. 'This is what I need to do is develop a product that would allow…people to learn the instincts needed for snowboarding.'"[90] Moscarello was a major presence at Bromley, first as an instructor, and then Vew-Do sponsored the Ron Emond Jib Fests at the mountain. Moscarello met Emond at JK Adams (a local wood-based kitchen and housewares company) while looking for wood for his boards. The two hit it off and spent hours on the mountain riding with Emond and his children. Upon Emond's sudden death at age forty-two, Moscarello supported his four children. One of them, Tyler Emond, started off a young Bromley boarder, worked with Scott Palmer at the Stratton Mountain School, became a pro rider and then worked at Vew-Do. Tyler, Ross Powers and the Glebeland crew were "the first of that generation to ride with the generation that was there in the beginning." While the Glebelands crew were older, they "came through and went on to do great things. Some of them worked here for Vew-Do, and this was their introduction into the snowboard world."[91] One of Scott Lenhardt's first professional pieces was a design for Vew-Do. "Brew was from Yonkers, New York," Scott Lenhardt continued, "so he had a whole different take on pretty much everything. And he was fun to hang out with when you're a teenager."[92] With Vew-Do bridging the snowboard and skateboard cultures seamlessly, Vew-Do appealed to many teenagers. Moscarello also saw a new potential for Snurfer. He discovered that Jem abandoned the patent for the Snurfer. "Yearning for that feeling of

Rider Curt Gurry and Shaun White were among the many riders who participated in the *Eastern Edge Magazine* fundraiser for the Manchester skate park. *Neil Korn.*

what brought us here," Moscarello launched Snurfer 2.0—"you know bindings aren't everything that they're made out to be."[93]

During the U.S. Open, *Eastern Edge* and Vew-Do Balance Boards sponsored benefit basketball games featuring pro riders, with all the proceeds going toward the funding of a skateboard park at the Manchester Rec Park. Like a star quarterback getting injured in a pre-season game, the basketball game claimed Jeff Brushie's ankle, negating his chances to compete in that year's half-pipe. Other mishaps and hijinks included Neil Korn getting pantsed by Seth Neary during introductions and Curt Gurry failing in a dunk attempt and heading to the hospital. Coach Andy Coghlan continued to display his competitive dominance well into the 1990s, as his squad accomplished a three-peat in the late 1990s. In 1998, Mountain Dew helped in the fundraising efforts, giving $5,000 to the cause, and today, the rec park remains as a testament to the efforts of Korn and Moscarello.

In 1997, Hayes Brothers Snowboards produced its first snowboards, capitalizing on their local legend status. The brothers opened a manufacturing facility in Londonderry. The company reflected the homegrown spirit of Jake Burton Carpenter a decade earlier. "Making the process even more unique, all of Hayes Brothers' employees are a part of the 'family' in one way or another, from the secretary Michelle, who happens to be Hayes's girlfriend [and future wife], to the production line entirely made up of team riders like Hobie Chittenden and Raschid Joyce."[94] In 2008, Hayes Brothers sold the company. Mike Hayes reminisced, "it was definitely kind of bittersweet. It was definitely time."[95]

Jesse Loomis combined his love of snowboarding and wood by creating Powderjet Snowboards. Seeing the decay in the snowboard industry, Loomis initially built handmade, wooden snowboards. "Through the combination of Shaun White's annoying success, Winter Olympics, Kevin Pearce's traumatic injury and kids 'throwing crazy tricks that almost didn't

The Libble-D hat became the unofficial uniform for southern Vermont for snowboarding. *Brian Knight.*

look fun anymore,'" Jesse felt that snowboarding was "an elitist sport that was unattainable by the general public."[96] Loomis believed that "the sport that I grew up with was migrating farther and farther away from its roots."[97] Snowboarding was no longer about "fresh tracks in the woods with duct tape, Sorrels and red beanie caps."

Cynthia Booth produced her first fleece "Libble-D" hat in 1992. Named after a "maneuver" popular among snowboarders on and off the slopes, the hat was "wardrobe staple in our stomping ground of southern Vermont."[98] Tirelessly promoted by her partner, John Gage, all through the day and into the night, Booth's creations became the unofficial uniform of the U.S. Open. While ubiquitous on heads in southwest Vermont, the lid also proved to be challenging to locate, but in most cases, one just had to ask the kind-hearted owners. In more than one instance, they literally gave the hat off their heads. "He [Gage] was always part of the scene, and he was friends with everybody. He can tell stories like the best of them, and he was never a pro but he was he was friends with all the pros," Steve Hayes felt that he "was very effective in promoting Libble-D lids. As he gained…popularity, he got some of the right people wearing the hats and would always come up with a custom hat and hook up the right people with the hats on the podium. John's definitely been a fan and part of the scene for many, many years. Built some great friendships and relationships around there." Rich Titus recalled, "Johnny Gage was funny like that. He could take one joke and beat it to death and beat it so much that it got funnier as he did it. One year he brought a rooster. He went around for three days asking people if they wanted to touch his cock. And by Sunday, it was hysterical."[99] Gage also had a profound impact on future Olympians. Betsy Shaw recalled that Gage "has probably been waiting nearly thirty years for me to admit that he was the one that convinced me to stop skiing and start snowboarding."[100]

NORTHBOUND TRAIN

In 1993, Burton moved its corporate operations northward to Burlington. As the company grew, using Albany Airport as the primary transportation hub was a hindrance to business operations. While the Burlington Airport was a huge selling point for Burton, the move provided other benefits. Chris Copley saw the problem with the small labor pool: "We had hired and fired every single person who lived down there that was under forty years old. Everyone has worked for Burton. They either f*&§ed up and they got fired or they were too stoned and they couldn't do their job anyway. The workforce was so small and you know we had so many needs."[101] John Thouborron agreed it was the labor pool but for different reasons: "There was no real industry around Manchester. It was needing creative talent and engineering talent. Burlington was a creative town, and UVM was cranking out engineers. The airport became that third component of it. It was mostly about being able to find talent. We were having a hard problem getting people to move to Manchester."[102]

Emmett Manning was considering buying a house in Manchester at the time of the move. Six months prior to the Chittenden County migration, Jake pulled him aside "and gave me a heads up and said you may want to hold off on that for a little bit."[103] Carol Plante felt that Carpenter "kept connected with people. He had a personal relationship with his staff. He engaged with us, and he asked how we were doing."[104]

After the company moved to the industrial park, the old barn became a place of legend. "At one point, we went to Jake's old house and checked out the barn." Mike Hayes recalled looking "at all the old Burton performers that they had lined up and there was just stacks and stacks of boards."[105] The barn was a myth among the fans. Many of Trevor Graves's friends "would steal those broken boards out of there, and I never did out of respect to Jake."[106] When Burton moved to Burlington, Emmett Manning rented a box truck to move the "thousands of uncut boards, cut boards, boards that were lacquered boards, boards that weren't lacquered, boards on the rack that were seconds." Manning pulled up to the barn and was

> *loading board after board into this truck.…It was July. It was a hot day. It was sweltering. The truck was pretty full, and I came out and the truck started to list in the backyard and unbeknownst to me, I parked it on an old septic tank. With the weight of all the boards in the truck, the thing was*

almost falling into the old septic. I was rushing around trying to get boards and rocks and stones—just enough to rock that thing out of there.[107]

When the boards made to Burlington, they served a new purpose. When Dave Schmidt arrived at Burton, the warped boards "went on to be collectors' items, and we started using them gifts for important dealers."[108]

Before heading north, Burton held one last hurrah. On the night before leaving Manchester, the factory "was completely cleared out and gutted." Emmett Manning continued, "Jake let us throw a rave in the factory. We went ahead and bought ten kegs from the bevy [Manchester Discount Beverage]." Andy Laats and Scott Richmond had a band, Hiplock, which WEQX described as a mix between They Might Be Giants and Red Hot Chili Peppers. The trio set up in the empty factory, "and we had the whole company in and they went 'til like four o'clock in the morning. I had to go back the next morning to pick up all the empty kegs and get the taps returned, emptied it out and locked up the place for good."[109]

6

PROGRESSION

SNOWBOARDERS AND THEIR CRAFT

CANNONBALL

Londonderry native Ross Powers first snowboarded behind the Londonderry Inn. He spent most of his free time at Bromley while his mother worked in the cafeteria. Spending the day on the hill, he recalled seeing "some lift attendants trying snowboarding at the end of the day before it was allowed there."[1] The following Christmas, Ross and his brother received a Burton Elite 130 board. After trying the Christmas gift at the Londonderry Inn, he went to work with his mom, where it was "pouring rain, probably only myself and one other person on the mountain," Powers recalled. Like Coghlan and Heingartner fifteen years earlier, Powers found himself on Plaza. Unlike the early crews, he did not have to do car shuttle runs at night, nor did he have to elude security. The lifts were open to the Plaza and Lord's Prayer runs. In contrast to the earlier generation, however, Powers "probably spent more time sliding down on my butt than the board. I fell in love that day, and that was it."[2]

Through Stratton's Allegro Program and the Green Mountain Series, he became more adept. Having never even watched a U.S. Open, Powers showed up to his first Open in 1989 as a competitor. His teacher brought his Flood Brook School class to watch Powers compete. He often joined the Glebelands crew at Bromley. "He would link up with us once in a while and show us up," Scott Lenhart recalled, "Even back then he was so solid.

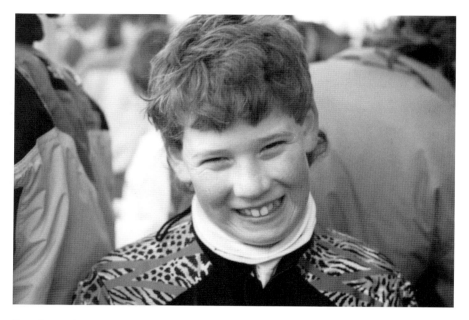

Ross Powers learned to ride while his mother worked in the Bromley cafeteria. *Tricia Byrnes*.

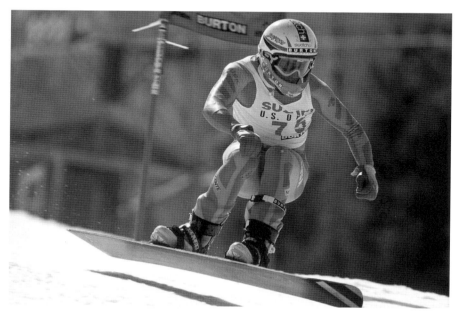

Manchester resident Scott Palmer started off racing and then transitioned to coaching. *Hubert Schriebl*.

By the end of the day, his run was so dialed in, and that transferred so well into half-pipe riding. He was a machine, that kid…solid."[3] Chris Copley remembered Powers as a "little dough boy. He ripped, but I would never ever have thought he would have….Then over one year, his whole body changed, and he started charging it and going for it."[4] Copley felt that the key to Powers' transformation was his entrance to the Stratton Mountain School and the coaching of Scott Palmer.

WE SALUTE YOU

During the early days of the half-pipe, there was certain level of intimacy. The scene was still far away from superpipes and *Rolling Stone* covers. There was a symbiotic bond between the riders and the spectators. The half-pipe was a spectator's pilgrimage; people often drove several hours to witness the best give it their all. Hobie Chittenden lived in upstate New York and often drove five hours to the U.S. Open, which was "bit of a hike, at the same time, but it was the U.S. Open. For the East Coast, or for anywhere at the time, it was a pretty big event."[5] Not only was it a highlight for the spectators, but it also was exhilarating for the riders. The riders put on the greatest show, partly to entertain the crowd and partly to strut their stuff to their peers.

A prime example of the early intimacy was when the U.S. Open fell on an Easter Sunday and dinner was served at the bottom of the course. "It wasn't uncommon for the Heingartners, the Hayes and Coghlans to get together at the finish of the U.S. Open," Steve Hayes recalled. It was much more of a mellow scene, as the families

> put out the ham dinner. We could ride up and join the party….This was a time when the snowboard factory was in Manchester. You had a lot of locals working at Burton Snowboards. So, you had a lot of Manchester people coming out to watch, cheer on their friends….We just had a lot of friends that would come out from the Manchester area with a backpack and a twelve pack of beer and park themselves on the sidelines to cheer on the U.S. Open competitors.[6]

When Ian Price completed the alpine competition, he did not retreat home. He simply shifted gears and put on his spectator hat. "I grew up watching the half-pipe. That was the biggest thing in snowboarding every

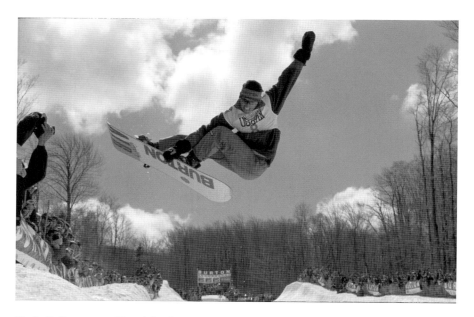

Craig Kelly was considered the first superstar of snowboarding. *Hubert Schriebl.*

year." Price attended his first half-pipe competition in the late 1980s. Once he became a competitor, his love of an afternoon leaning on a snow fence did not recede. "My buddies would all come in from all over southern Vermont. We would go to the half-pipe and have a great time....It brought you right back there with the U.S. Open had always been about until then."[7]

One local rider who went big in the pipe was Hobie Chittenden. In 2017, Ross Powers stated that "he was a legend around here....He was a really talented guy."[8] In 2000, Neil Korn called Chittenden "the most grizzly, dirty, hardcore redneck you'll ever meet" who "almost always smells from motor oil, but never B.O."[9] Chittenden learned to snowboard in 1987 in upstate New York and came over to the U.S. Open as a spectator. Chittenden said, "I caught wind of the snowboarding thing somehow, and I needed to look into it a little bit more."[10] With such humble beginnings, Hobie progressed through the sport. Powers continued, "He was good all-around athlete....He did it all back then. It wasn't his favorite, but he could do well racing and then freestyle, he could just charge and had such good style and such good pop and go big."[11]

A fixture on the half-pipe was announcer Chris Copley. While holding various positions at Burton, including marketing, sales and team manager, Copley was in many regards the face (and voice) of the U.S. Open. Copley

Above: Hobie Chittenden drove hours to watch the U.S. Open before becoming a competitor himself. *Skye Chalmers*.

Right: Chris Copley worked in marketing but really made a lasting impression as the half-pipe announcer. *Neil Korn*.

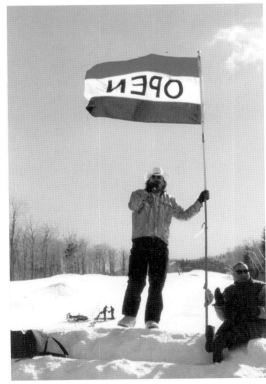

recalled his initiation: "Nobody else would do it. I have a big mouth, and I said give me the %#&*& mic, I will do it."[12] With his knowledge of the riders and their moves, Copley was perfect for the job. "Some of it was crowd control too. When people started [to] whip it snowballs and stuff, I had to threaten that I would beat the *&§! out of them. I had to calm people down when everyone's getting really rowdy."

There was a special connection between the athlete and spectator. Trevor Graves felt that one of the best aspects of the competition was that "the fans were right there as the athlete would walk up." Despite the presence of a fence, the fans "could high five them and talk to them and they would engage going up and down the pipe. It became very interactive between you and your sports hero. Like in basketball, forget it, you can't even touch them."[13] Tricia Byrnes agreed: "It was intense, but it was laid back....You felt really connected to the energy of the event. The riders and the crowd were kind of one sport. Everyone was in it together. And I used to love that...hiking up the side of the half-pipe and seeing all the people that were so psyched."[14]

CHANGE OF THE GUARD

The introduction of the half-pipe signified a sea change at the U.S. Open. Mike Hayes recalls in the documentary *Powder and Rails* that

> as soon as they introduced the half-pipe, that's when we started to see the crowds show up. Basically, the whole event started to gravitate towards the freestyle events, just because that was the real crowd pleaser. It's a lot more fun to watch the half-pipe than it is to watch some slalom races. And so eventually, they phased out the alpine events, and that's pretty much when I retired [laughing]....*They retired me.*

When Tricia Byrnes first started, "the scene was way more alpine....It was more about downhill and Andy Coghlan going super-fast and bombing Suntanner. I just switched with the times....The freestyle scene was way more my vibe than the alpine scene....Everyone was too serious in alpine for me. I was just like 'I'm done.'"[15]

Chris Karol recalled that the lack of media coverage for alpine snowboarding had diminished the racing program and that the "freestyle

community had flipped the middle finger to alpine snowboarding, and sponsor opportunities were drying up."[16] So many of snowboarding's first-generation snowboarding Vermonters were adept downhillers—Andy Coghlan, Jack Coghlan, Mark Heingartner, Steve Hayes and Tara Eberhard, to name a few. In a piece of irony, Craig Kelly, the man identified as a freestyle innovator, whose signing with Burton represented a transformation in Burton's mission, was the last winner of the U.S. Open downhill, in 1989.

While there was a change, many riders continued with the alpine events. Ian Price "grew up with Ross and John and all those guys" and "would all get together, we would all ride soft boots, build jumps and go ride the half-pipe." When it came to competitions, Price felt that "because my background had always been ski racing, I just gravitated that direction."[17]

The great holdouts to the West Coast freestyle invasion were the European boarders. In retrospect, the influence of Europe on the U.S. Open should come as no surprise. Stratton Mountain is steeped in Austrian tradition, ranging from the stucco and half-timber architecture to the Tyrolean singing of the Stratton Mountain Boys. Appropriately, European carvers were the highlight of these early U.S. Opens. While the West Coast surf and skate influence allowed Americans to dominate the early half-pipe events, the traditional alpine events belonged to the Europeans. They had a definitive, fluid style but seemed like outsiders. During the early years of the U.S. Open, the primary competition continued to focus on the alpine-based events, with two Europeans, Peter Bauer and Jean Nerva, capturing the spotlight.

The Europeans' biggest influence on the scene was the hard boot alpine style. "The first year there was maybe one or two people from Europe," Mike Hayes recalled. "Then they started to show up with guys like Jose Fernandez, Peter Bauer, Jean Nerva—all the guys on the Burton team that were doing really well in Europe. And so that raised the bar considerably in terms of competition."[18] Scott Palmer added, "To me, there was a little bit of animosity, because they were great…and for us being the best Americans, the Open was our chance to make some money. And then Burton would send over all these Euros and they would podium—'What the %&*! Keep those f*&§ers in Austria! We need this money.'"[19] In response to Palmer, John Thouborron remarked, "He's joking, but he wasn't….The European competitors, in terms of alpine disciplines, certainly dominated."[20] Thouborron credits this domination to the gradual eastward expansion of the freestyle movement. Firmly planted in the West, it took a while to take root on the East Coast and considerably longer to cross the Atlantic Ocean, resulting in the Europeans reigning supreme in alpine.

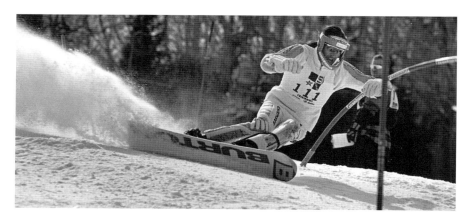

German Peter Bauer and other Europeans such as Jean Nerva brought a distinct carving style to the sport and were difficult to beat in the race events. *Hubert Schriebl.*

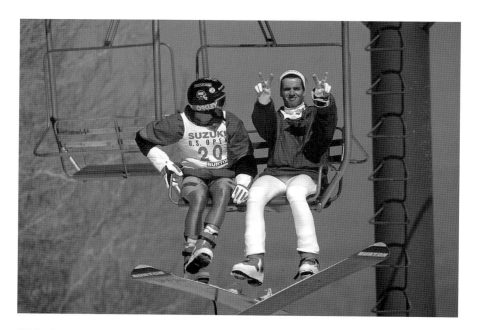

While fierce competitors, most snowboarders shared a camaraderie on and off the slopes. Peter Bauer (*right*) and Mark Heingartner (*left*) riding the lift between runs. *Hubert Schriebl.*

Peter Bauer recalled loving the United States, "however it felt very strict being in a US ski resort. No out of bounds, 'slow,' signs, lots of liability waivers to sign. And no beer on the terrace....We really needed to adjust, coming from Europe. The event was fun, lots of spectators, good organization. And good burgers."[21] Upon their arrival, Bauer felt a little bit of a cultural clash. "They gave us shit—in a funny way—for our clothing," Peter Bauer commented, "Vermont skiers all had dark blue jackets and pants. The Euros were all in pink and purple."[22] Chris Copley thought Peter Bauer was "the best....That dude is so rad, so smart." Jean Nerva, who attended the Sorbonne to study music, was a "musical savant." Copley continued, "Those two guys were so intellectual and so smart and so much different than the knucklehead American snowboarders."[23]

BOYS FROM THE NORTH COUNTRY

In the 1980s, six adolescent skateboarders from Chittenden County used Burlington's concrete jungle to hone their skills. Consisting of Cole Bouchett, Josh Brownlee, Jeff Brushie, Matt Lawrence, Greg Manning and Kris Swierz, the Chittenden County skateboarders soon embraced snowboarding, using Bolton Valley as their center. Andy Coghlan, the Zelig of Vermont snowboarding history, and his brother, Jack, recruited them for the Boarding House Snowboard Team. The crew eventually became known as the Vermont Slope Posse (VTSP). Under the Coghlan's tutelage, the VTSP competed in the Green Mountain Snowboard Series and New England Cup Series. Kris Swierz recalled that the Coghlans "pretty much put our whole little crew under their wing from the get go. We were little skate punks. We were just starting to snowboard. They turned into being our snowboard coaches and showing us the ropes and touring around the East Coast."[24] In 1991, VTSP member

Jeff Brushie and the VTSP crew brought northern Vermont skateboard ethos to southern Vermont. *Hubert Schriebl.*

and Burton team rider Jeff Brushie was crowned World Champion. Brushie was one of the first East Coast snowboarding superstars, as his snowboarding style possessed an "uncanny ability to maximize airtime, seemingly effortless trick execution and stylish flair both on and off the slopes."[25] While a native of northern Vermont, Brushie helped transform the reputation of the U.S. Open. "Brushie would always full on represent in those sessions," recalled Jason Goldsmith. "He always showed that this was his turf. It was always a show when he dropped into the pipe."[26]

PARTY TIME

THE OTHER SIDE OF SNOWBOARDING

CAN'T FIND THEIR WAY HOME

In the early days, the sport personified the party culture of the time. Often compared to hippie free spirits on the snow, snowboarders' night life was more akin to *Animal House*. Parties were symbiotic to the local competition scene. The U.S. Open was a gathering of the tribes, an annual pilgrimage that brought together like-minded, fringe people who rarely came together as one. Andy Coghlan was not only a leader on the slopes, but he established a precedent in the evenings as well. Being more the Sultan of Swig then the Sultan of Swat, Coghlan was considered "the Babe Ruth of snowboarding. He could party like a rock star and then win an event the next day."[1] Scott Palmer explained, "There was a certain feel that you weren't really part of the competition unless you were a part of the party the night before." It was almost as if it was the competition before the competition. In some regards, it was a part of the competition—the night and the day. Palmer continued, "It was more of a camaraderie where if you nerded and went and slept and waxed, you weren't as credible a competitor as somebody who was having fun the night before." After a day of outdoing one another on the slopes, the competition segued into the nightlife. "And then it was like you had a whole other contest," Trevor Graves recalled, "who could funnel the most, drink the most."[2] Palmer joked, "You were cheating if you weren't partying."[3]

Shaun Palmer was a frequent competitor at the U.S. Open in the 1980s and 1990s, "yet Palmer was known for his off-hill antics…He was foul

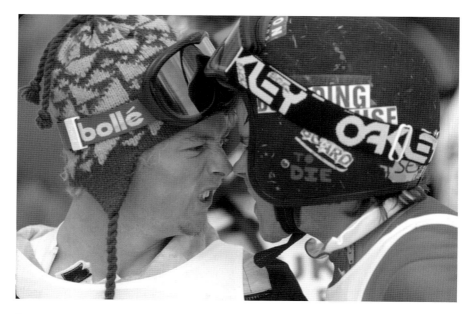

Early riders Andy Coghlan (*right*) and Shaun Palmer (*left*) were competitors all day and all night. *Hubert Schriebl.*

mouthed, hugely opinionated. And he set the standard for partying—he was the sort of guy who'd stay up all night drinking and then win a half-pipe competition the next day."[4] During the 1992 U.S. Open, Palmer was involved in a late-night dual car slalom up the access road. Palmer was driving in a rented Sims team van while his challenger drove a *blue* school van. The two cars passed each other several times, exchanging leads until they got to the crucial left turn for the Hayes house. The challenger was knowledgeable of the local roads and engaged into a left turn. Palmer, the out-of-towner, felt one more pass was necessary. The end result was the vans clipping each other and Palmer's car flipping. To many of the witnesses, there were legitimate concerns for fatalities. The challenger recalled Noah Salasnek, a passenger in Palmer's car, standing on the crashed, flipped van "with his hands in the air chanting how they were crushing it."[5] There was a period of confusion and panic as there was a flipped car and a school van with a door off its hinges. The failed racers returned to the Hayes household with various scrapes and bruises. Bob Klein recalled, "Palmer and Salasnek look[ed] like they had glitter all over their faces from all the broken glass— not a scratch on them. Just laughing their asses off, they thought it was the funniest thing ever."[6] The involved parties quickly concocted a story about

avoiding a dog. The following day, the cops conducted their investigation, tracing the car back to the Sims team rider's mom and then to Palmer's hotel room. "They track them down, and he's like 'Oh, the dog ran out in front of me,' and the cops were like 'Was it a *blue* dog?'"[7]

While the American snowboarders certainly wanted to outperform the Euros on the mountain, there was no love lost. Europeans such as Jean Nerva and Peter Bauer "were [a] little more sophisticated then we were… and probably still are."[8] As the years went on, the Americans and Europeans became more tight-knit. In the beginning, there was a feeling that they were "over here to kick our ass, and there was a little competition," Scott Palmer explained. "But I think over the years we got to know them."[9] The sophisticated European was not a view held by the Vermont law enforcement agencies, as evidenced by a brawl that occurred following the 2000 Open at the Stratton Mountain Inn. A group of Europeans "got really drunk, and they were partying to all hours in the morning," resulting in a call from the manager and then a visit from the grossly outnumbered local police. The inebriated snowboarders jumped an officer, who promptly "ran away and hid in a closet and called for backup."[10] The state troopers showed up and arrested three Austrians, two Swiss and a Czech. The arrest of a Pennsylvania man prevented a European sweep of the available jail cells. The police charged Austrian Martin Freinademetz with aggravated assault, while the remainder pleaded innocent to various charges.[11] Windham County chief deputy Henry Farnum told the *Associated Press*, "It was wall-to-wall people, and they all wanted their pound of flesh….I've been calling it 'melee on the mountain' all day."[12]

Over a given U.S. Open weekend, there were successive parties at Haig's, often switching back and forth between public and private affairs. With the ever-present combination of state troopers, sheriffs and Winhall police, the wise (or simply already too wasted) did not dare to make the journey down to Bondville to the Red Fox or Haig's, thus making the Green Door Pub in the Stratton village the unofficial official drinking locale of the U.S. Open. For anyone down in the valley in Manchester, the choice of attending a U.S. Open party was a heavily weighted decision. Were you going to attend the party of the year and risk "running the gauntlet"—the twenty-minute drive up Routes 11/30 and the access road, which involved driving through the jurisdictions of two towns, two counties and the omnipresent state troopers.

MISTY MOUNTAIN

The party wasn't relegated to the evenings. During the U.S. Open, the spectators and competitors would often revel through the nights, and come event day, the party was brought to the slopes and pipe. Like being in the end zone seats for a Cleveland Browns or Oakland Raiders game, where the seats are littered with rabid fans, the left side of the half-pipe had a similar vibe. There was a U.S. Open version of the wave involving a volley of "FUs" from one side of the pipe to the other. As the competitors hiked up the side, they would invariably be handed beers during their ascent. During one U.S. Open, Seth Neary hiked the left side, and "they were handing out 40 ounces of beer and you would take a couple of pulls off of it....If you hiked up the right side, you were staying away from that and you were going to be sober." Neary concluded, "I definitely chose the left side."[13]

For the spectator, watching the U.S. Open was an art form that developed over the years. "You stand in one spot all day, and you'd wear sneakers up there." Jesse Loomis continued, "Your feet would freeze. It would be icy, you fall down the slope and you'd lose your spot. Sort of hectic."[14] In time, the spectators learned to dress accordingly, to arrive early to claim prime

The half-pipe was a much anticipated event by both competitor and spectator. *Brian Knight.*

During the mid-1990s, the half-pipe competition party was superseding the competition. *Skye Chalmers*.

viewing spots and, perhaps the most important of all, to bring the drinking gloves. As we will discover later, the homemade drinking platforms and kegs would soon roll their way up the pipe. A cooler full of grain alcohol made its way to the crowds one year, creating twenty-foot circle of inebriation. In the base lodge, there was a game where somebody, often unsuspectingly, got the lowest playing card and was forced to eat raw garlic.[15] Paul Johnston "knew when they were coming.…There was a group of people that would drink quarts of beer and eat garlic so they could come and burp, fart and stink."[16] Competitor Ian Price had a tour van equipped with bean bags. During one U.S. Open, he emptied the beanbags, filled them with cases of beer, "threw it over our shoulder like Santa Claus and walked out to the bottom of the half-pipe."[17] Price recalled one year that fans were "breaking beer bottles over their heads and lighting bottle rockets off and just shooting them off into the crowd.…It got pretty wild."[18]

Announcer Chris Copley often found himself calming unruly crowds, but sometimes the crowds just went too far. During the 1994 Open, the spectators hurled snowballs at Copley and the other officials, who were located up in the wooden officials' platform, known as the mushroom. After one snowball hit Copley in the face and knocked his trademark cowboy hat off his head, Copley showed little concern for the fifteen-foot jump and "dove right over the rail and grabbed the kid.…The crowd went nuts."[19]

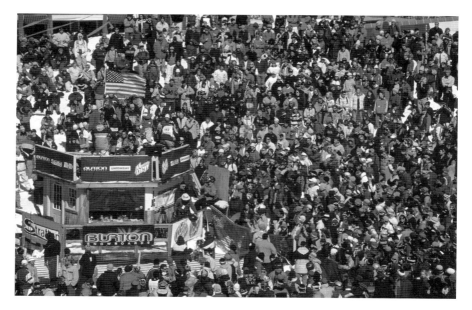

Long before cellphones, one could easily lose one's friends at the U.S. Open. *James Schriebl.*

The half-pipe revelers left a swath of litter in their wake. *James Schriebl.*

During the 1999 Big Air event, spectators from each side of the jump's landing started to exchange empty beer bottles. John Conway felt that the exchange would "work out great if the people throwing the bottles would hit only one another." He continued, "I guess anytime you get this many people together you will have certain shitheads that are too stupid to have fun."[20] During the 2005 evening rail jam, a reporter from *YoBeat Magazine* "began with a shot gunning beer party in the parking lot and sneaking in even more beer in snowboard pants." The reporter reasoned, "An evening on the slopes can get chilly even when bundled in high-quality outerwear, so a little buzz to keep you warm may be necessary."[21] Colin Whyte of *X-Games Online* wrote, "Mix one part 'Super Troopers' with equal parts open-container law violations and some of the best competitive snowboarding of the season and you have that heady cocktail known as The Open."[22]

One enterprising writer came up with a drinking game in which participants had to drink for a variety of reasons, including every time someone talks about how much better the contest used to be; every time someone calls Ross Powers a hometown hero; every time someone claims Stratton as their hometown but is actually from Connecticut; every time someone asks if you're going to a Hayes brothers' party that night; and every time it's one of the Hayes brothers asking, pound a beer.[23]

SHOOT THE MOON

There were several known locales for hanging and partying. Matt Mitchell was a common denominator in many of these houses. He lived in an A-frame on Route 100, then shared a home on Lower Taylor Hill Road with Russell Winfield and finally lived in his family condominium in Winhall Acres. One year, there was a party at Lower Taylor Hill Road house to celebrate Craig Kelly's birthday. The revelers "smashed the cake in his face. And he was walking around with the cake in his face." Neil Korn continued that Shaun Palmer thought "the keg was kicked, so he got pissed and threw the keg out the back-screen door and broke the door."[24] Seth Miller came down to the U.S. Open as a spectator and ended up at the party and "in the door comes Craig Kelly with a giant boulder ice ball, belly to the belly with Palmer, with no shirts on. They were walking around the whole house daring each other who was going to pull away first and drop it."[25] In the basement, the partygoers took beer bottles and threw them against the wall, and "there was a pile of thousands of beer bottles broken in one part of the basement."

Most evenings started in the afternoon at Grizzly's. *Brian Knight.*

To give them credit, it wasn't simply throwing bottles at a wall, as there was a game involved. Given the name "Pull," the game's participants threw "a whole glass six pack up in the air and [would] throw a bottle at it, like it is a shotgun."[26] Kris Swierz remembered that "the party got out of hand, and we had a clean-up in the morning with shovels. There was a foot of frickin' glass in the living room from everyone just smashing their beer bottles. It turned into the craziest party ever."[27] Matt Mitchell said it simply: "The house was out of control...nonstop out of control...every night."[28] While maintaining a reputation for his revelry, Mitchell was a top-notch instructor and performer. "He was a huge influence in my early years of snowboarding," Tricia Byrnes recalled. "He just wanted it so badly. He took it really seriously. He was a really good, good friend of ours."

A popular hangout was the Crack Den, located behind Haig's. This three-bedroom house served as the home to riders Seth Neary, Seth Miller, Jim Moran, Doug Byrnes, Alvah Wendell, Kris Swierz and the Fusco brothers. The moniker came from the general lack of hygiene. "It's almost like a family." Seth Miller felt that the Crack Den "kind of looked like one. It was pretty rough. We didn't do any crack. We were college kids basically but not in college. The weekdays were pretty mellow, and the weekends got even more exciting, a constant guess of who rolled through."[29]

Seth Neary (*left*) and Seth Miller, residents of the Crack Den, lived and rode together 24-7. *Tricia Byrnes*.

"They were disgusting and basically all 7-Eleven or Grampy's food," Tricia Byrnes recalled, "teenage…twenty-something year old, disgusting boys." Located within walking distance to Grampy's (7-Eleven in 2017), the Crack Denizens found themselves frequenting the store for their meals. "They had those little Grampy's burgers, and you've got those for about a dollar or a dollar-twenty-five," Seth Miller continued, "and beer…and try to throw a vegetable in once in awhile."[30] Seth Neary added, "If you had 59 cents, you could get the microwave cheeseburger….Nobody had money." According to Seth Neary, the Crack Den folks "were filthy…Somebody was always dyeing their hair, somebody was piercing something, drinking anything."[31] Due to the combination of limited space, teenage male snowboarders and little elder oversight, the den primarily was a crash pad lacking maid service. "We would get 40s every night and come back, watch snowboard videos… pretty much a big sausage den, I don't think a girl ever walked in the door," Kris Swierz added, "Tricia might have walked in the door once and then walked right back out."[32]

While never living up to its moniker as a true crack house, the house managed to be party central, just without the crack. "You don't have to name names," Korn recalled, "but you can say that there were some wild times there."[33] While stories of bad hygiene and late-night antics may be

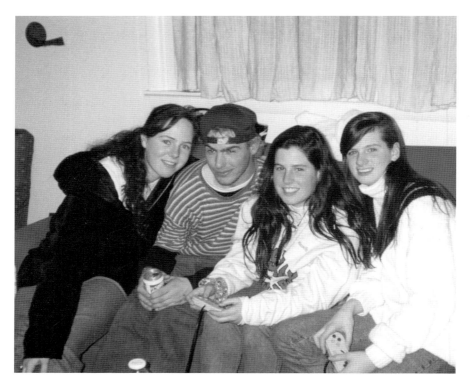

While the Crack Den was more of a crash pad, it was also known for its social events.
Tricia Byrnes.

entertaining, the bottom line was the residents and their craft. "That house was probably the most progressive group of snowboarders at the time." Seth Neary continued, "It was a four-bedroom house with like twelve people in at a time....You know what, if I could click my heels and go back in time, I would be right there."[34]

Just about anyone's house or condominium on the mountain served as a party locale. With so many riders staying in their family's homes, there were plenty of parent-free weekends, a green light for a party. Todd Davidson's house was site of "some pretty crazy parties....There was this big, big boulder in our backyard and you could drop off....We had this huge bonfire, and people were kicking off his rock, jumping over the fire....How we all survived, I don't have a clue but it was a good time for sure."[35] Foley remembered "never hitting the jump....I recall people nearly cracking their skulls."[36] Scott Johnston continued, "Everyone had their house parties.... [They] were like a shred party too—someone built a jump in the back.

126

Someone would get rid of a couch. We lit a couch on fire, and they built a jump in front of it. Then jumped over the couch that was on fire. It was Jackass shit, but we weren't paid for it. Who could one up each other. Who could front flip into a pile of returnables."[37]

At the Byrnes residence on Quarter Mile Road, Doug Byrnes maintained his own private enclave in the basement. He had a large bedroom with four bunk beds, a couch and DJ turntables. "My brother would get away with everything," Tricia Byrnes recalled. "I would be like 'Mom, Doug is basically having a party downstairs!' She was like 'Oh well'....There's people that come up to me now and are 'We stayed at your house.' So many people used our house as a crash pad. It was only my brother's portion of the house....It was like his own apartment in our normal house."

During the U.S. Open, the late-night revelry shifted to the Hayes brothers' house, which was "the exclamation point on the U.S. Open."[38] The annual event was a "mixture of fraternity meets snowboarding. It had that sort of college feel...just dirtier."[39] Starting out as a house party that produced hungover competitors and spectators the next day, then transforming into the marquee event held in Mulligans or Grizzly's, the U.S. Open and a Hayes brothers fête were synonymous. In the early days, the party raged in the basement while a modicum of civility occurred upstairs. It was a part of the process—speaking to the parents around the roaring fire—it could have been a photo shoot for a Stratton marketing brochure. A journey down the stairs was a step into mayhem and hedonism.

The first Hayes brothers party was held during the 1986 U.S. Open, thanks to liberal parents "who thought an early education [in parties] was good so we would be ready for college."[40] They set up a keg in the basement, "and everybody was there—all the competitors." Steve Hayes recalled that "Donna [Carpenter] started a game with a dartboard....You would throw a dart and whatever your dart landed on was the number of keg laps you had to do. And the big loser that night was Shaun Palmer, who hit twenty. He had to do twenty laps. I remember Jake doing keg laps on his knees and that was the beginning of the Hayes brothers' parties."[41] Mike Hayes recalled that at one U.S. Open awards ceremony, "when everyone else was going up and thanking their sponsors, Shaun Palmer went up and he said 'I'd like to thank the Hayes brothers for the party last night.'"[42]

"The Hayes party was legendary when I was growing up." When Tricia Byrnes went to her first Hayes party, she "felt like an impostor, I was like 'Oh my god they're going to kill me and kick me out'...because I was quite young. Not that they cared."[43] Byrnes and Beth Trombly "were so nervous

about going in. We would drive around and around and around and then we finally went in."[44] For the young riders, the Hayes party was often a brush with stardom. Tricia Byrnes entered the party and saw "Craig Kelly and all those guys. And it felt like you had snuck into an Oscars party." Scott Lenhardt snuck into the Hayes brothers' parties "when I was probably way too young…and watched Shaun Palmer and Jeff Brushie partying." Like many other people, Lenhardt was more of spectator than a participant, watching the shenanigans while "hiding in the corner."[45] Matt Mitchell read about the parties in *International Snowboard Magazine*, which was a call to action, "I was like 'I can't wait. I'm going there. This is what I'm going to do.'"[46]

Neil Korn recalled a guy from Maine whose "main objective was to come to the U.S. Open and to fight Shaun Palmer."[47] One night, he went to the Hayes house shouting "Where's Palmer?" The objective of the man's violent desire wasn't even at the party yet. "Shaun never did anything to him." Korn continued, "He was just this crazy kid from Maine that wanted fight him because Palmer was famous snowboarder that got into a lot of trouble."[48] Steve Hayes recalled that the guy encountered Andy Coghlan, resulting in a "few face shots and throwing him out."[49] Everyone thought the situation was remedied and returned to their regularly scheduled raging in the house. The guy ran to his car, burst back into the basement party and sprayed mace in Coghlan's face. With this escalation, the whole party chased him out of the house, and he hid under the car.

> G-Man grabbed him by the ankles and dragged his ass out from underneath the car. Russell Winfield and others started taking shots on this guy and telling him "Don't *&^% with the Hayes brothers." Someone else reached into the guy's pocket and grabbed his car keys and hucked them into the woods—deep four feet of pack—those were gone. The guy got the shit kicked out of him and limped off with his girlfriend.[50]

To access the Hayes home, there was ramp leading to the front deck, where there was a popular hot tub. One year, people launched from the adjacent garbage hut "into the hot tub doing front flips," resulting in water "splashing all over the ramp and deck." The police arrived, prompting a mad rush inside to quiet things down. Steve Hayes didn't "know how we did it, but we got the message for the DJ to stop the tunes and everything to be quiet." The scene quickly turned from impending doom to the Keystone Kops. Three police officers walked down the ramp,

and "The middle cop slips on the icy walkway, kicks out the cop in front of him and knocks down the cop behind him." With three cops lying on the ground, "we're all in the hot tub trying not to laugh. Unbelievably, I think because they're so embarrassed, they just gave us a warning and were not there very long. And they got up and told us that there was a noise complaint but didn't see much going on, and they left."[51] Ian Price remembered the same hot tub: "We were getting a little chilly, and the hot tub looked inviting, so I ended getting in the hot tub with my jeans on that night. No alternative as to what I was going to do after that, but it seemed like a good idea at the time."[52]

Not only was the house a party zone, but it also was a crash pad during the U.S. Open. "The door was open to anybody. Absolutely anyone that walked in the house. I didn't know that....The year before I stayed in a field in my Subaru and it was like thirty below," remembered Kris Swierz, who stayed at the Hayes house "during one of the U.S. Opens, and there was forty people sleeping on the floor....They got a big living room downstairs, and it was packed full of people just sprawled out, sun coming up."[53]

One year, Ride Snowboards "knocked off the Hayes party thing" and to some, the party "slaughtered them for the most iconic party ever" at the U.S. Open.[54] Like so many parties during the U.S. Open, the Ride party followed a similar pattern of being "somewhere off the access road," Shaun Palmer engaging in destructive behavior and, finally, needing shovels to clean up the aftermath. Ride Snowboards planned to "bring everything we have to U.S. Open and to own Vermont...that's going to be a major shock to Burton."[55] Shem Roose showed up and witnessed Terje Haakonsen and Shaun Palmer getting into a beer spraying fight, which was "an intimidating scene to be in....I wasn't a pro rider, and I was just there as a nineteen/twenty-year-old kid working for Burton."[56] Jason Ford added, "Brushie came and he brought his DJ friend, and he started spinning....The house got destroyed....The house was detonated. Palmer ripped kitchen cabinets down. He was peeing all over them in the kitchen. We had to clean it the next day with snow shovels because there were so many beer cans." Windows were broken, and when the partygoers left Vermont, there were twenty-five bags of trash on the front stoop and little prospects of getting the deposit back.

While the party atmosphere dominated the image of the early snowboarder, there were exceptions to the rule. For many, it was a lifestyle choice. "I definitely went to some parties, but it wasn't my main objective," Betsy Shaw recalled. "I didn't want to feel like garbage the next day."[57]

When Jason Goldsmith was in the Stratton area, he did not have "really any crazy social life up there.....I was never really one of those people at the party."[58] Brew Moscarello "didn't go to many of those crazy bashes… it wasn't my thing."[59] For others, age was a hindrance to the nightlife. Ross Powers "always heard the stories of the party the night before, and they would be up on the hill talking about it a little bit. I was young at the time."[60] Ryan Foley "was just a kid.…I barely drank.…I was a good little Catholic boy from New Vernon, New Jersey."[61]

Over time, the Hayes party consumed the entire house, and life became unmanageable. "It became pretty evident that it was a liability issue with the party," Steve Hayes remarked. "We had a lot of people coming and staying with us and people who were old school pro snowboarders knew just to show up at our house," as they "check into the hotel and then go over to the [house and] see what's going on. And I had Pat Bridges from *Snowboarder Magazine* come out to me one year, and he said the quote of the weekend was 'Are you going to the Hayes party?' We knew that it was getting out of control."[62] Scott Palmer observed in 2017, "Toward the end at the Hayes brothers, it was like 'How many hours can we go before the cops are going to come?'"[63]

When the Hayes brothers launched their own snowboard company, their party was the must-go event of the weekend. One of the biggest testaments to its magnitude occurred when Steve Hayes went out to the SIA Trade Show in Las Vegas. He was playing roulette at a casino when he started talking to three guys. When it came to part ways, Hayes inquired whether the trio was heading to the U.S. Open. They responded, "No, we are not going out for the U.S. Open. We are going out for the Hayes Party." At that point, Steve introduced himself, and he ended up forming a strong business partnership. "With Hayes Brothers Snowboards," Steve Hayes said, "it just really kind of fit with the party scene. We were the anti-Burton, anti-industry startup that was trying to be disruptive." Hayes recalled a Hayes brothers party at the Green Door Pub when Chris Copley from Burton approached Steve Hayes and said, "'You know I don't know how you do it…every year you seem to outdo us with the parties.' And he basically surrendered at that point. Here was Burton with all this corporate money and they could not outdo the Hayes brothers when it came to the parties."[64]

LIVE WHILE YOU'RE YOUNG

While a major conflict during the early years of snowboarding was with the skiing class, a subset of that particular antagonism was age. Skiing was the old ruling elite, while snowboarding represented the youth movement. It is nothing new in American history. During the 1950s, there was the youthful rebellion represented by Elvis Presley, James Dean and the perception of emerging rock-and-roll as devil's music. Twenty years later, the Beat Generation and then the 1960s counterculture was an outlash against the conservative post–World War II America. Throughout history, the cultural differences may differ, but a generation gap is a constant.

"I really feel like there's something so cool about that time at Stratton and just being able to grow up with the mountain as your backyard where you had free rein." Tricia Byrnes continued, "We weren't skiing with our parents all day. We were in our posse of snowboarders…at this super contained place and running amok on the mountain."[65] Still in high school or fresh out of high school, the youthful snowboarders enjoyed their freedom. "We were snowboarding nonstop to try to be pro snowboarders, trying to put in the time," recounted Kris Swierz. "None of us had jobs, and it was bare bones snowboarding. That's all we did."[66]

In the 1990s, a tradition percolated at the U.S. Open in the form of stickers. Like a schoolyard prank of sticking "kick me" on the back of unsuspecting students, U.S. Open revelers targeted police officers. One spectator recalled a naive trooper walking the room while unwittingly getting plastered with a sticker stating "I Love Butt." As he patrolled the room, the officer was oblivious to the reasons behind the laughter that accompanied him. The 1998 Open featured "Toddzilla, the Norwegian Killa," "Better Dead than Red…USA #1" and "Barrett Christy, Not Just Good, Good Looking." In 2000, the stickers included commentary on other fringe cultures ("Phish Phuckin' Sucks"), inducement to inebriation ("Beer is vacation in a can," "Have you seen my liver?" "Fuck the Contest…I came to Puke"), teenage sexual desires ("Got Milf?," "My Other Ride Is Your Mom" and "Sleeps Well with Others"), respect for the fallen ("Byrnes") and not so much respect for the washed up ("Shannon's Dunn"). A memorable Open featured placards of Vince LaVecchia and buttons stating "I slept with Vince LaVecchia." Brew Moscarello mused, "For some reason, Vince was the face for that year.… They were everywhere. It was a big thing.…Everybody loved him. He's just a sweetheart."[67]

The greatest display of adolescent behavior often occurred in the courtyard, the transitional space between the base area and the village at the U.S. Open. The hotel, where the majority of competitors stayed, formed one half of the courtyard. Following the half-pipe finals, the riders returned to the hotel, while hundreds of spectators gathered for an autograph session. Rather than descend back down to the courtyard, the competitors often threw their gear down to the eager and often inebriated crowd. The transition to the courtyard was a chink in the crowd control plan. When the half-pipe ended, the masses were left without an activity or a diversion. Rich Titus recalled, "The pipe is over at two o'clock, and next thing you know, all the snowboard reps are staying in the village lodge and throwing stuff out the windows…and causing little mini riots. They would throw swag out their windows so people would run over to grab it." Titus added that the reps had a touch of maliciousness to them: "And then they'd throw buckets of hot water out."[68]

During one memorable courtyard session, Terje Haakonsen opened his fifth-floor window and took his half-pipe winning snowboard, dangled it out the window and tossed it to the eager fans below. Similar to the reception

When Terje Haakonsen tossed his board to the crowds below, a near riot erupted in the square. *Skye Chalmers.*

132

that young girls displayed for musical icons ranging from the Beatles to One Direction, the spectators clamored for the board and a fight broke out. Surprised that nobody was killed by a tumbling snowboard from sixty feet above, Tom Monterosso recalled, "Every cop from down in that area was called in because people were just beating on each other."[69] Somehow, among the drunken melee, "A young kid clutched the deck, beaming with excitement as he ran away, knowing all too well not to stick around with it after a ten-minute battle."[70]

GOT TO CALLING IT HOME

In time, the U.S. Open became an institution. It was a destination for the spectator as well as a place of familiarity for riders—ground zero for the sport's progression. "Not only did you have the home field advantage, because you knew the half-pipe," Seth Neary added, "but the locals were the best fans on the planet too. You're not only getting cheered on by the locals, you're going to go and party with them after."[71] The U.S. Open was a homecoming for many pro riders returning to their home turf. Ross Powers recalled that all the Burton riders came home for the holidays, and "there was a heavy crew that would come back and ride. Stratton used to try to get the pipe open around the Christmas holiday, so they would come back and shred that."[72] Seth Miller and many other competitors "felt more comfortable...you're surrounded by people that were stoked. A lot of old friends. Everyone was hoping you did your best. It was definitely like a home field kind of feel coming back to the U.S. Open."[73] For many local competitors like Byrnes, Price, Powers and Hollingsworth, competing in the U.S. Open was special because their family came to the slopes, they reunited with their pets, many slept in their own beds and ate a home-cooked meal for the first time in a long time.

With their international competition schedule, the U.S. Open was often the only time that Ian Price and Betsy Shaw returned to Vermont. The two grew up at Bromley, so they often used the mountain as a training center prior to the Stratton events. To Price, the familiarity of Vermont was beneficial to local riders. In addition to the comforts of home, "sitting on a chairlift and looking around and knowing exactly what you're looking at—'there's Bromley...There's Magic or there's my buddy's house'" had a profound mental impact that allowed the riders to be "completely relaxed,"

which offered "a huge advantage." This advantage translated in great results for the Vermonters. Price recalled getting a lift with Ross Powers in 1997 after winning the Super G race. To Price, it was a surreal moment, as he and Powers, who were certified seven years earlier at Bromley, were excelling on the international circuit and "taking it to a whole another level." While the half-pipe seemed to attract the fanfare, Price felt the love way at the top of the mountain as well—"You knew you were being watched by a bunch of family and friends that makes it cool too to have that kind of support on the hill."[74]

"I felt like we were a part of something. It felt so cool," Tricia Byrnes reflected.

> *There was this huge movement that felt bigger than us. It wasn't like we were starting it. We were so excited to be part of it. Having people from around the world, people who you saw in magazines for snowboarding, which was just so cool, come to your home mountain—It felt so acceptable. You were competing with them. It was the perfect timing where you got to have movie stars all of a sudden come and be a part of your life and then you were like "oh my gosh we're part of the movie now."*[75]

When Seth Miller competed in the 1992 U.S. Open, he rode with many people he respected: "You kind of thought you were part of the crew. It was fun to drop in with those guys. You ride with them and you find out they're humans just like you and end up making friends with most of them."[76] Ian Price came from a ski racing background, "where it's a lot more competitive and not quite as friendly," and with snowboarding, "no matter how competitive we all were, it was always a friendly thing at the end of the day." He continued, "You're stoked for your buddy. Everyone wants to do well but at the same time you're pumped for your buddy to hear them either land a new trick or get new sponsor....There was a lot more being happy for someone rather than being jealous or envious."[77] Price felt that the fledgling snowboarding scene "introduced us to all these super friendly, fun people that we always wanted to be around. We wanted to go compete but we also wanted to go hang out with all our friends. That was like the coolest thing about snowboarding. It wasn't just about the event. It wasn't just about the result."

To Dennis Healy, the U.S. Open "was something that we always look forward to. It was ours. It was our sport and we understood it brought a lot of likeminded people together for a good thing to celebrate snowboarding

As the new millennium approached, the U.S. Open was synonymous with large crowds. *Skye Chalmers*.

and to have some fun riding and compete and watch some sick stuff....It was an amazing time to be a part of the sport."[78] To many people who were at Stratton in the 1990s, they would consider that time to be "the best time of their life because you're in a relatively new sport, but the progression of the sport was really starting to take hold." Seth Neary continued, "You had a bunch of likeminded individuals coming from all over New England to one spot because of a half-pipe...to progress snowboarding, to try things that hadn't been done before, to really push the limits."[79]

In 1992, Jason Goldsmith competed in the USASA Nationals at Stratton early in the week, and with a second-place finish, he advanced to the U.S. Open that same week. To Goldsmith, the Friday jam session before the Open was a snowboarding pinnacle. "Your elbow to elbow with all the pros. You are the area local that represents this area. You know this area. This is where you live. This is your backyard. You're going to ride with these [pros] on the same level as them." Goldsmith continued,

> *You become more progressed as the session kept going. You are going a little higher. You're spinning a little further. You're progressing as you're riding. That was the awesome part about riding on Fridays there before the contest. That was the most fun. It was kind of an all-out pipe jam. You would get into a train of four or five riders dropping and hitting the same hits all the way down.*[80]

For Ross Powers, who has a cabinet full of awards and medals, the U.S. Open holds a special meaning: "I can't say it was as big as winning the '02 Olympics because the Olympics are so big, but within snowboarding and me personally growing up around the area, going to watch the Opens as a kid, that's definitely up there as one of my biggest ones."[81] When the U.S. Open was over, the following Monday was often a free-for-all in the pipe. "The day after the Open was always a big deal." Scott Lenhardt recalled one year "sessioning [*sic*] the half-pipe with everybody. Anyone could just walk up there. There was one backside that was gouged out on the backside wall and everyone was hitting that over and over."[82] Lenhardt convinced his mom to take the day after the U.S. Open off from school to ride with fellow Glebelander and Burton rider Randy Gaetano. Lenhardt hoped to get a sponsorship, but what he really received was a day riding with Jim Rippey, Terje Haakonsen, Bryan Iguchi and Dave Downing. For their first run, "no one turned, it was a bomb session down the whole mountain. And I remember just trying to keep up...freaking out."[83]

The excitement was not only relegated to the riders and spectators. For Stratton employees, although it was hard work, they looked forward to the annual event, as it was "the culmination" of their season. Keith Hannum and his crew had "about two or three weeks of events in a row in the spring time and the Open was kind of the end of it, and we were wrapping up the season. You'd come out of it with your tan and you could kind of relax a little bit when it was done."[84] For Rich Titus, "I never not had fun. I loved it." Even though Titus and company labored with putting up banners, dealing with TV cables, putting up endless lines of B-Net, they always kept their spirits. The U.S. Open was all hands on deck for Stratton employees. "We needed the guys from the road crew, we needed any lift ops…any lift mechanic, anyone who could ride a snowmobile helped pull these events off."[85] After working eighty hours during the week, the employees blew off some steam. Following the events, the lights stayed on and the crew had full reign of the terrain features. "For an hour, a couple of cases of beer and guys riding gym mats down, taking the quarter pipe," Rich Titus recalled. The half-pipe and quarter pipe became the favorites for the snowmobilers. "Any time you had to go anywhere up or down you went through the pipe and you rode the pipe on the snowmobile like you would on a snowboard."[86]

DON'T BOGART THAT POACH

Like stadium streakers, the Stratton U.S. Open had its own version of diversionary entertainment. The Stratton half-pipe poach was an institution within the institution; it was the fringe element to the fringe sport. The poacher came in many forms. Once the final rider completed his run in the half-pipe, the U.S. Open truly became open, as the legions of fans descended down into the legendary pipe, an annual but chaotic ritual. During the competition, there were many television timeouts. Just like in a football TV timeout, there is a period of silence and inaction. Half-pipe announcer Chris Copley recalled "so everyone's standing around….It broke up the whole flow of the event. And then a couple dudes were like, 'Hey, I don't care. I'm just bombing it.' And they would cut under the fence and charge it. And the crowd would go so berserk."[87]

Abe Teter of Belmont, Vermont, was the king poacher. Carpenter comments in the documentary *Powder and Rails*, "You've got to have a certain amount of balls, and Abe Teter, I think, probably gets the best career

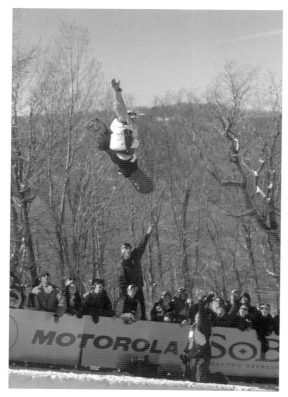

Left: There was none better at poaching the half-pipe than Vermonter Abe Teter. *James Schriebl*.

Below: Mike Michalchuk, known for massive airs, giving back to the fans after a day of poaching. *James Schriebl*.

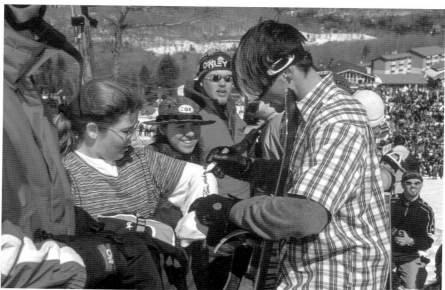

poacher....That guy just always went huge and people loved to see him ride so nobody ever complained about him."[88] The poaching was yet another symbol of snowboarding's transition from the fringe to the mainstream. By the 2014 U.S. Open, the poachers were actually sanctioned riders, pre-selected to hit the pipe during commercial breaks.

BEHIND THE GREEN DOOR

The Green Door Pub, located in the basement of the clover-themed Mulligan's, is a windowless shrine to the U.S. Open. While the great legends of snowboarding have left their mark on the grounds of Stratton, it is hard to get "sense of place" while on the mountain. Although one can traverse the slopes that once served as the base for memorable slalom, super-G, Big Air, rail jam, half-pipe and boarder cross competitions, it is hard to feel the history. A journey down the slightly curved steps and a sharp left into the Green Door is akin to stepping into U.S. Open's hallowed grounds. While Vermonters such as Coghlan, Heingartner, Brushie, Clark, Teter and Powers made their impact at the Open, it is the dense, often beer-soaked aroma of the Green Door Pub that evokes a tangible sense of heritage and tradition. In the depths of this room, competitors and spectators, carvers and jibbers, Goofy and Regular, Burton and Sims, even skiers and snowboarders came together to create a whole new legend. They seem to be essential rites of passage for U.S. Open spectators—watching the half-pipe finals and a night at the Green Door.

Arriving in Vermont in 1992, Pete Christy assumed management of the Green Door Pub, already located in the basement of Mulligan's but yet to attain its present identity. Christy made the Green Door accessible for the snowboarders and skiers. In the early days, there wasn't as much money flowing around as there is today. Being a pro snowboarder in 1994 was not going to get you on the cover of *Rolling Stone*. "So we did things like free nachos on Wednesday, steak and brew, which was a cheap eat. We always had a cheap beer on tap or in the can," Christy explained. If there was a snowboarders' Field of Dreams, Christy built it, and they came. "The snowboarders made this place what it is. They came in and then I embraced it....I wouldn't say it was all snowboarders down here. but it was like a let your hair down bar....It was the clubhouse for snowboarders for sure...still is."[89]

The Green Door Pub was the epicenter for après activities and the unofficial U.S. Open Headquarters. *Brian Knight.*

"The Green Door is as much a part of the scene there as the half-pipe. You went down there and that's where you saw all your friends. It had all the memorabilia on the walls. It had the stickers on the walls. It had the pool table. It was the perfect pub for the snowboard culture." Seth Neary added, "And it's not like it alienated the skiers to come to that bar. It wasn't like that. It wasn't a snowboard only bar but when you went there, you definitely felt like 'This is where I'm supposed to be.'"[90]

For many, the Green Door Pub was the perfect hangout during the midweek. While there were big parties held at Haig's or the Red Fox and there was broken glass, fights and police occurring elsewhere, the Green Door Pub was a great alternative. For the people who weren't invited "or disenfranchised from some of the bigger parties," Christy said, "you could always just come in the Green Door Pub." Even the pros found the relative accessibility of the Green Door Pub much better than the big parties. Christy recalled that what "we would get was a lot of the female pros—Tina Basich, Barrett Christy—would like to hang out down here. And then some of the other pros who didn't want to go to the big parties." When the weekend arrived, however, the Green Door transformed from alternative hangout to the place to be. "We didn't get crazy like that here until the weekend, you know Saturday night when everything was said and done, this was the place."

While the Green Door during the U.S. Open was also an invitation to long lines to get in, the bar crowded three–four deep, endless stacks of quarters on the pool table and a high probability for getting ejected or knowing someone who got ejected, the bar is a mainstay throughout the ski season. In 2013, *TransWorld SNOWboard Magazine* declared the Green Door Pub the number one après ski spot in North America.

FOXTROT

The Green Door Pub is the instant gratification for revelry. The Red Fox Inn is for the more seasoned and adventurous. In 1960, Michael Kidd, a successful Broadway choreographer, bought a former sheep farm and converted it into an inn. He named his new venture the Red Fox Inn for all the foxes than roamed the seven hundred acres.[91] The Red Fox Inn is the oldest thing in this narrative as it predates Stratton, the invention of the Snurfer and the first U.S. Open. The Bondville tavern is a true institution that erases any skiing/snowboarding rivalry, and "locals and city slickers alike have been piling in for the last fifty years because they know it carries a vibe like nowhere else in the region."[92] The Red Fox Inn is the best place to drink a Guinness beer, eat Irish stew and listen to Celtic music. The greatest experience at the Red Fox Inn is the constant slideshow documenting years of camaraderie. The present owners, Tom and Cindy Logan, moved to Vermont in 1975 and worked locally making sandwiches at "The Deli" and tending bar at the Red Fox. The Boston Irish couple organized the Bondville St. Patrick's Day parade in 1976 and took ownership of inn in the early 1980s.

The Bondville St. Patrick's Day Parade invariably occurred the same weekend as the U.S. Open. *Brian Knight.*

While parade origins were on the fringe, the parade evolved into a community event featuring local floats such a "bathtubs and go-carts, snakes and bears, horses and llamas, and even some Irish wolfhounds, Batman in his bat mobile and of course, fire engines."[93] The parade traditionally ended at the Red Fox Inn, which offered corned beef and cabbage, Irish soda bread and lots of Irish music into the wee hours."[94] When St. Patrick's Day and the U.S. Open occurred on the same weekend, the parade and celebration could either be a welcomed alternative or the final leg of a U.S. Open Superfecta of Half-Pipe/Grizzly's/Green Door/Haig's/Red Fox. Only the truly initiated could add the Hayes brothers party as a bonus. When St. Patrick's Day arrived after the U.S. Open, the celebration served as a debrief (but not necessarily a detox) for the weekend's events.

BACK IN THE CHICKEN SHACK

As the competitors eventually got more serious about the sport, the revelry transferred to the spectators. The 1996 U.S. Open was known as "The Year of the Cage." Mark Sullivan and Pat Bridges, editors of *East Infection Magazine*, wanted to make the half-pipe final a legendary experience. "One night, over a couple of cold beers, Pat Bridges and I formulated the idea for the Cage," Sullivan explained. "We wanted to replicate the scene in the movie *The Blues Brothers* where they were playing a gig behind a chicken wire fence while the crowd shelled them with beer bottles. Only for us, the idea was to keep the beer bottles from hitting the riders."[95] Prior to the final, the *East Infection* crew took its van on a detour to New Hampshire to buy some tax-free alcohol in the form of approximately forty cases of Country Club Malt Liquor tall boys.

The *East Infection* squad rose early, dragging chicken wire and two-by-fours to the pipe. Their plan almost ended early on, as an employee approached them. Instead of being told to turn around, the quick-thinking Pat Bridges said, "We're creating a private viewing area for Burton employees. And the guy's like, 'Oh, really? Can we get you anything? You guys need some trash barrels? Some chairs? Some tables?' And we were like, 'We need all of the above.'"[96] Soon thereafter, they built their own chicken wire–encased beer garden/viewing area on the deck.

With a firm early beachhead at the pipe established, the cage evolved into a full-blown rager. It was almost as if the partying that defined the U.S.

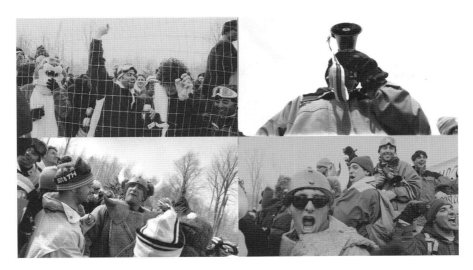

To some, the Cage was the U.S. Open spectator apex moment. *Skye Chalmers*.

Open had migrated from the Hayes basement and planted itself firmly in the spotlight. The denizens of the cage spent the day imbibing heavily and cheering on the riders. Even the riders participated in the revelry. Someone handed Seth Miller "a beer every time I hiked up the pipe. So, I switched to the other side."[97] For others like Jason Ford, they stayed clear away: "Any of the partying that went on during the day, I was immune to it, because we were there to compete and try to do well."[98]

Unlike the event that provided the context for their revelry, the Cage was not an open event. Apparently, there was a bouncer keeping the newbs out. "By the time the finals rolled around, the Cage was totally out of control." The revelry leaked out beyond the chicken wire. Sullivan continued, "And it was time for phase 2—to bust out the mascot uniforms. When Pat and I got back with the mascot uniforms on—it all broke loose."[99] Bridges put on his show, heading down the pipe in a tiger uniform doing "eggplants and his weird hand plant variations in that pipe, trashed....And it's hard enough to walk down the road wearing a tiger costume drunk, and he was rolling in from the deck, doing inverts in that costume. And that's just mind-boggling."[100]

Eventually, the makeshift beer garden did not survive the amateurish carpentry skills and the sheer volume. If there was a building code for chicken wire, half-pipe, beer gardens, this one did not meet it. Finally succumbing to the chaos, the cage broke, and people fell off the back of the half-pipe.

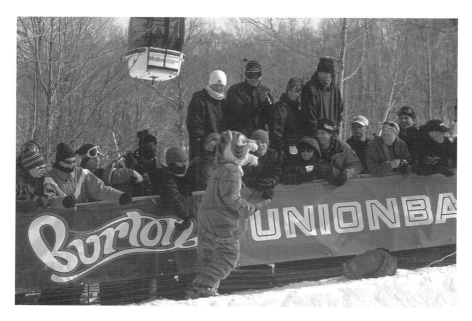

Pat Bridges and Mark Sullivan, editors of *East Infection* magazine and Cage brainchildren, donned animal costumes, hit the pipe and put on their own show. *Hubert Schriebl.*

Two "Friends of the Cage," John Gage (*left*) and Matt Mitchell (*right*). *Skye Chalmers.*

Miraculously, nobody got hurt, as the revelers tumbled into the crowds below. Mark Sullivan recalled, "The cage collapsed, empties skittered down the walls of the pipe, bodies spilled out in every direction and the finals got put on hold until some semblance of order was restored."[101]

The whole event transpired with little oversight, which was a reflection of where the U.S. Open was at the time. It was still a blip on the radar. Dennis Healy commented that Stratton

> *definitely didn't have any clue as to what was going on. I wonder what Stratton's perspective on the whole thing was at that point anyway. They probably weren't making that much money off of that. They were probably just like "Alright you guys, you &***%$ delinquents, go over there and do your thing." When Burton got way more involved, and it started to get corporate sponsorship and it became this big to do. They sort of prairie dogged out of their hole and started to pay attention.*[102]

While there may be many indicators that signified when the U.S. Open jumped the shark, to Dennis Healy it was right around 1996, as "there was sort of an innocence lost, it can never be as fun as it was especially after the Cage. That was a U.S. Open spectator apex moment."[103]

GROWING PAINS

DARKNESS GOT TO GIVE

During the summer of 1969, two events served as bookends for the counterculture movement. The summer began with Woodstock and ended with Altamont. While Woodstock was the embodiment of peace, love and music, Altamont brought the era to an end. Altamont was plagued with problems: a last-minute change in venue, poor planning, lots of illegal substances and the Hells Angels hired as security. The event was mired in violence and tragedy. During the concert, there were isolated events of violence culminating in the death of an attendee. In many ways, the U.S. Opens of the late 1990s were the Altamont for the event. While the Hells Angels were never hired for security, the riots at the Opens of 1998 and 1999 expanded beyond kegs and snowball fights, as guns were pulled and the musical acts' bodyguards took the law into their own hands. Rich Titus recalled that when kids threw snowballs at Big Pun, his bodyguards went out into the crows seeking the culprit. One bodyguard sat on the stage as a spotter, and the other bodyguards maneuvered through the crowds, zig-zagging left or right until the person was found and "the guy and kid who threw the snowball disappeared. I couldn't tell you where they went. I couldn't tell you if he got his ass kicked but next thing you know, you never saw either of me again. And then sure enough, some other dickhead would throw a snowball."[1] Just as Grateful Dead and the bands of San Francisco sound came to a realization that the bubble of their unique and intimate

The half-kegs at the half-pipe. *James Schriebl.*

scene had been burst, the U.S. Open, as it headed into the new millennium, had reached a new level.

Almost ten years after Paul Johnston staved off angry snowboard-hating homeowners, the problem reintroduced itself to the president of Stratton Corporation, Bob Fries. The problem was no longer snowboarders not looking uphill during their heel side turn; the problem was now the F-bomb resonating at level 11 across the valley. Bob Fries recounted that a band was playing "in front of the base lodge with the speakers the size of Volkswagens." Fries was on the hill when he started to hear the constant refrain of curses blaring out of the base area, prompting Fries to put his skis on "as fast as I could, skied to the bottom, and immediately pulled the plug." Fries then wrote a letter to Stratton season pass holders, employees and merchants. He pointed out that fact that Stratton received great media coverage, but "on the negative side," there was "on hill drinking…a lot of trash, several loud parties and some fast boarding on our trails." Fries called the band "off color," and fortunately, he "got the band off the stage after about thirty minutes, but the damage was done."[2] It was the new popularity that pushed the envelope. Stratton attempted to deal with the growing popularity with security fences, added personnel and, ultimately, the moving of the venue to the more remote Sun Bowl.

During the seventeenth U.S. Open at Stratton, violence percolated among the spectators. The U.S. Open experienced profound growing pains. Rich Titus felt that the early U.S. Opens "were low key…and then it got bigger, which meant the party got bigger. And it started to get more out of control. I remember when the event was over, guys were riding kegs down the center of the pipe."[3] With the half-pipe ending at 2:00/2:30 p.m. and music often not starting until 4:30, there were hours of downtime in which a horde of inebriated spectators needed a diversion. The spectators came from the half-pipe and gathered in the base area "with nothing to do but sit there and heckle the skiers trying to come home at night."[4] Keith Hannum remembered "one group was pouring…I don't know if it was alcohol or what it was…something on top of those sawhorse ski racks…and lighting them on fire."[5]

During the 1999 Open, the news of tragedy permeated through the half-pipe finals. Two spectators, Rob Carr and Jake Shumway, made the journey to Stratton. Like so many spectators, they did not have proper lodging. Being resourceful and adept outdoorsmen, they dug a snow cave in the parking lot. During the night, a snow removal machine dumped snow on their shelter, instantly collapsing the makeshift abode. They were found the next morning, dead from asphyxia and hypothermia.

COMING OUT

As early as 1987, there were rumors of snowboarding at the Olympics. The 1992 Albertville Olympics came and went, with Albert Tomba gaining the headlines but not Craig Kelly. And then the 1994 Lillehammer games came and went. The 1998 Nagano games served as the coming out party. Snowboarding, along with curling and women's hockey, debuted at Nagano. Ryan Foley used to get ribbed by his older brother: "Ryan, midget kick boxing will be in the Olympics before snowboarding." When Nagano came around, he approached his brother, who admitted he was "eating crow."[6]

Three southern Vermont snowboarders—Betsy Shaw, Ross Powers and Ron Chiodi—made the journey to Japan. Carpenter was a reluctant spectator at Nagano, as he considered it "a bittersweet experience" in which the garage rock band suddenly gets a record deal. The money and exposure seem great until somebody suddenly tells you to wash your hair, wash your

Betsy Shaw started her snow sport days at the Bromley Outing Club. *Hubert Schriebl.*

clothes and, no, you can't sing that on TV. Carpenter was "afraid...that snowboarding won't be fun anymore."[7]

Shaw and Powers were competing on an International Ski Federation (FIS)–sponsored World Cup leading up to the Nagano Olympics. Moving to Vermont in 1993, Chiodi made the team through the pre-qualifying process. While traveling the world at the time, Powers recalled Chiodi from hiking the pipe at Stratton: "He rode hard, he was a good athlete that came in and rode the pipe hard, go big, had good tricks."[8] Powers also remembered Shaw from his Bromley days, as he and John Kelly were "setting gates and getting the opportunity to train with them over at Bromley, which was really cool when I was pretty young."[9]

When they arrived in Nagano, the snowboarders were removed from the core of the Olympic experience and sequestered up in the mountains. While geographically isolated, the media was omnipresent. Being the new kids on the block, the snowboarders were under close media coverage. The press focused on the half-pipe riders, using terms such as "landlocked surfers," "tattoos and multiple body-piercings," "peculiar vernacular" and references to the stoner movies *Half-Baked* and *Bill and Ted's Excellent Adventure.*

For some of the Vermont contingent, the inaugural Olympic games were a mix of emotions. Shaw, who disqualified, recalled her Nagano experience:

Above: Ron Chiodi was one of three Vermont riders at the 1998 Nagano Olympics. *Hubert Schriebl*.

Right: After his bronze in Nagano, Ross Powers returned to Salt Lake City in 2002 with an unfettered determination to win gold. *Vermont Review*.

151

"I was initially devastated by my failure to perform at the Olympics…but remembered my promise to myself that, as long as I rode all out, with no holding back, I'd have no regrets. And I did that. I took a risk and didn't get away with it. You either win the Olympics, or you don't."[10] Going into the Olympics, Shaw "had some serious doubts when I realized you had to do it through the FIS. That was a downward spiral for me, spiritually, as far as how much fun I was having with snowboarding when that all happened. It did change the dynamic of everything. And it got very political."[11]

Although Nagano resulted in a bronze medal for Powers, he felt he didn't fully embrace the Olympic experience. He left the games a day early to get home, and "that's when I realized how big the Olympics were because I couldn't go to the mountain or the grocery store without it being a big scene." It was at this time that Powers said he "told myself if I ever get a chance to go back to the Olympics, I'm going to go there and do the whole Olympic experience, go to opening ceremonies, go to closing ceremonies, go to as many other events as I can and take the whole thing in instead of rushing out early"[12]

While snowboarding was one of the biggest media draws, the Nagano Olympic debut was full of controversial media bits. The best snowboarder in the world, Terje Haakonsen, boycotted the games, protesting the relationship between FIS and snowboarding. The IOC stripped the medal from the first gold medalist in snowboarding history. Canada's Ross Rebagliati tested positive for microscopic amounts of marijuana (seventeen billionths of gram), but since the substance wasn't technically banned, the IOC reinstated the honors. More media coverage focused on two female members of the U.S. Team refusing to wear the national team outfits at breakfast. Besides the media coverage, the half-pipe was held in the pouring rain, and the IOC even spelled *snowboard* wrong. Carpenter, who spent so much of his professional career promoting the sport, witnessed a less-than-illustrious coming out party in Nagano. He recalled years later: "Japan just did not go that well.…It was kind of a disaster."[13]

BROKEDOWN PALACE

As America entered a new millennium, the U.S. Open experienced growing pains. In 2000, the Fourth Annual X-Games were held in neighboring Mount Snow. While the U.S. Open was considered a bigger event, the X-Games

brought in more sports, more television coverage and a wider appeal. The X-Games and the U.S. Open were held within a few weeks of each other, creating a scorched earth between the two ski areas. "When the X Games landed on Mount Snow, that town got leveled," recalled Pete Christy.[14] The party simply moved northward, and Stratton was in the swath.

Starting in 2001, there were hints of a dissolving relationship. After a disastrous string of U.S. Opens featuring pulled out guns, flying bottles and burning ski racks, Stratton moved the half-pipe to the Sun Bowl. Hailed by many as the secret back door to Stratton's crowds, many did not like the idea of competition moved to the isolated but self-contained area. Stratton always wanted it in the Sun Bowl. During the Open, skiers went to the Sun Bowl to avoid crowds. "There is only so much that you can do in the Sun Bowl," Rich Titus recalled, "and eventually you really need to get back to the base area, especially if you're renting condos there. It really made sense to move it the Sun Bowl. It took Burton a couple of years to finally come around to it. But once we moved to the Sun Bowl, then we were able to get even bigger."[15] According to a *Transworld Business* article, "it just doesn't feel like the Open without the old Stratton pipe on the far right of the resort, where drunken fans of snowboarding crawl all over like ants, infesting trees and even lift towers, and frightening vacationing families and high-end clientele alike." With a new location, security bag checks and the polished television-ready production, the U.S. Open was markedly different. There was a loss of intimacy that Dennis Healy summed up succinctly: "I went every single year from probably '89 on, until they stopped allowing you to drink beer on the side of the pipe."[16] While it seems like an inconsequential change, it was symbolic of the U.S. Open's evolution. To Healy and so many others, the U.S. Open had gone mainstream. The ability to drink at the pipe reflected the larger-scale change. Healy "understood that you can only stay like that for so long. It was inevitable for other people to get involved in the sport."[17]

For the 2003 U.S. Open, over thirty thousand spectators showed up. During the 2010 Rail Jam, the "beats blared from the DJ tower" and "the crowd got rowdier and rowdier as time passed" and "more than a few peeps get pulled aside and kicked out for throwing snowballs and causing a ruckus."[18] After the awards, musicians performed outside, "playing for the wild crowd filled with underage college kids and tweens." The performers "stopped their set after some idiot threw a snowball (of course) knocking over the DJ's computer on the stage."[19] The evening parties got larger and more crowded. Unlike walking through the Hayes brothers' sliding glass door in

the 1990s, these U.S. Open parties invariably involved long lines, frantic searching for VIP passes and, once inside, wishing you were somewhere else.

It was not all riots and violence during this era, as the competitors consistently lived up to the Open's legacy of superior athleticism. While Shaun White received most of the limelight, the local talent who excelled at the Sun Bowl is impressive. Ross Powers and Kelly Clark both achieved their second half-pipe titles, and names such as Hannah Teter, Louis Vito, Ellery Hollingsworth and Lindsey Jacobellis became part of the snowboarding nomenclature. Between 2001 and 2009, Danny Kass won an unprecedented five U.S. Open titles. The Frends crew, consisting of Mason Aguirre, Kevin Pearce, Scotty Lago, Keir Dillon, Mikkel Bang, Jack Mitrani and Luke Mitrani, made their marks on the snow as well as in the summer months, with their greatly anticipated Frendly Gathering, a music festival and much more, held in Windham, Vermont.

GOLDEN ROAD

With the 2002 Salt Lake City Olympics, the U.S. snowboarders had an opportunity for redemption from the 1998 games. This time, Ross Powers and Tricia Byrnes represented Vermont. When Tricia Byrnes first started snowboarding, she often thought,

> "Oh yeah I would love to go to the Olympics but that's never going to happen." We were barely allowed on the mountain! To think that we were walking into the Olympic stadium in the U.S. and we were top billing. It was insane to feel that in a matter of ten years, something that you started just for fun on weekends, all of a sudden, it's on the main stage at the Olympics. It is kind of crazy.

During the competition, Powers said to himself, "I just want to do the biggest air out of anyone here today." He lived up to wishes, as he "did the biggest air I've ever done and followed it up with a great run and held on for the rest of that run and the whole next one."[20] While the home nation advantage was a bonus, it was the presence of family that helped Powers. Unlike in Nagano, Powers was surrounded by his mother, brother and other family and friends. When Powers "was hiking up the half-pipe in the morning, I saw my mom for the first time on that trip. She was on the side

Ross Powers's 2002 gold medal brought newfound fame for him, as Lego made a life-size representation of the snowboarder. *Brian Knight.*

of the pipe with my brother." Powers asked his mother, "What are you doing tonight?" Mrs. Powers clearly had faith in her son's abilities, as she replied "Going to the award ceremonies."[21]

MOUNTAIN (SCHOOL) JAM

There is a whole generation of future Olympians roaming the slopes of southern Vermont. Former competitors are now passing their skills and knowledge on to the sport's future. Andy Coghlan, Patty Edwards and Chris Karol established a snowboard camp at Loon Mountain in the late 1980s. Soon thereafter, Jack Coghlan and Jeff Brushie started the Eastern Snowboard Camp. Ron Chiodi created the American Snowboard Training Center (ASTC) in 2008, and Raschid Joyce coaches the Stratton Snowboard Competition Team.

The Stratton Mountain School (SMS) has been a farm system for snowboarding's top performers. Founded in 1972 as an alpine program, the school steadily established itself as the premier academy for alpine skiing, freestyle skiing, Nordic skiing and snowboarding. Even before the school had a snowboard program, Doug Bouton, Steve Hayes, Tara Eberhard, Jack Coghlan, Andy Coghlan and Suzi Rueck all passed through the halls as skiers. Steve Hayes snowboarded in his free time and was not allowed to claim snowboarding as his full-time sport. He signed a contract guaranteeing his commitment to skiing. Eventually, SMS realized that snowboarding offered much more opportunity and success, and he was released of his skiing bonds. The school eventually realized it needed to adapt to the times. In the early 1990s, Autumn Ahlers competed in snowboarding while enrolled as a skier. According to Ian Price, Ahlers was "a really strong competitor," but his racing career was cut short when he "hit his leg on a snowmaking pipe and broke both the bones in his lower leg."[22]

After a few years of professional racing, Manchester resident Scott Palmer ran Stowe's snowboard program and then joined Carrabassett Valley Academy. Palmer was approached by the headmaster at the Stratton Mountain School, who said he was starting a snowboard program and he "kind of got the word that you'd be the man."[23] Palmer became the school's first snowboard coach, but not without an awkward transition. SMS could not hire Palmer as full-time staff, so it arranged for Stratton Mountain to hire Palmer, and he also took over the Allegro Program. He oversaw the

Steady competition forced Ross Powers to do his homework in the unlikeliest of places, such as the offices of *Eastern Edge* magazine. *Neil Korn.*

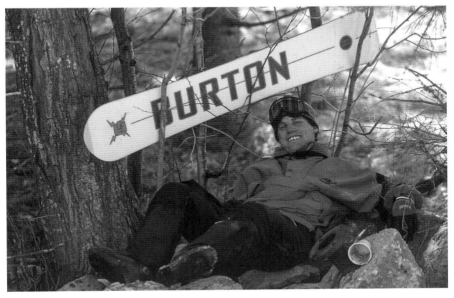

After coaching Ross Powers at the Stratton Mountain School, Scott Palmer went on to to run the Southern Vermont Snowboard Series. *Hubert Schriebl.*

SMS program with five inaugural students, including Ross Powers. During the fall and spring, the snowboarders trained with the skiers and then worked with Palmer in the winter. Chris Copley attributed Powers's success to Scott Palmer. "Palmer made Ross Powers what he is, coaching and just pushing him," Copley continued, "He became an incredible athlete and really made it happen. Scott Palmer should get a lot of that credit because he made that happen."[24]

The school produced many future Olympians. Pete Thorndike '96 competed at Salt Lake City Olympic Games. Kiwi Kendall Brown '08 represented New Zealand and finished twenty-fourth at the 2006 Olympics. Lindsey Jacobellis '03 dominated the snowboard cross circuit for nearly a decade, culminating in a silver at the 2006 Winter Olympic Games. When the 2016 Olympic Games arrived in Sochi, Russia, fourteen Stratton Mountain School alumni participated in the games, including snowboarders Danny Davis '06, Louis Vito '06, Canadian rider Alexandra Duckworth '05 and Jackie Hernandez '10. The biggest local name to rise out of the Stratton Mountain Snowboarder alumni at the Sochi games was bronze medalist Manchester resident Alex Diebold '04.

LEAVING TRUNK

Within three months of the final Sunday events at the 2012 U.S. Open, Burton announced that the event was moving to Vail, Colorado. In an interview with *TransWorld SNOWboarding*, Burton's Greg Dacyshyn stated that the company felt "like it's time to evolve the event for the riders, spectators, for anyone that's involved and provide them with the best experience they can have." To Burton, Vail was the "obvious choice," and management "consulted with many different people and organizations before making a move like this, it's a big move, and everyone has been 100 percent behind it."[25] The Vail facilities were projected to hold close to five thousand people and had the infrastructure for concerts, entertainment and on-mountain kid's parks. With these goals, there were too many logistical and planning roadblocks ties to Stratton. The Vermont brand can often launch a business but rarely can sustain it.

The move to Vail was a "break in tradition" that according to X Games Online, "[heralded] the end of an era in snowboarding." For years, "conditions ranging from fog to sub-zero temperatures to sleet and ice

storms" plagued the U.S. Open, which "tormented competitors at Stratton for years." The sport had assumed global popularity, "and while Vermont once was the epicenter of snowboard culture, and the U.S. Open the crown jewel of contests, the globalization of the sport" forced a change. As more and more competitions filled the annual calendar, "traveling to the Open's remote location has become less of a pilgrimage and more difficult for today's competitors and spectators to pull off."[26] The idyllic backwater Vermont brand that contributed to Burton's growth came full circle and nipped the industry in the butt.

When Pat Bridges reflected on the move to Vail, he placed the move squarely on the shoulders of the mountain:

> *The naysayers shouldn't be pissed at Burton. They should be pissed at Stratton. The X Games or Dew Tour obviously didn't see the level of support necessary to keep their events in New England, yet no one is giving Disney or Pepsi grief about it. As a steward of our sport, Burton is once again being held to a higher standard, and they should be. Yet the fact is that Burton diligently tried to make it work for three decades at a loss. It is simple: If Stratton wanted the U.S. Open, it would still be there.[27]*

Carpenter recalled that Burton had troubles with the Sun Bowl location, and he wanted to "progress the event." "I wouldn't say it was necessarily Stratton's fault. It was just the dynamics and the economics. Vail as so receptive and ready to do what it would to keep progressing it."[28]

EPILOGUE

DEAD TO THE CORE

For the 2011 U.S. Open, Burton parodied the Grateful Dead's album cover from 1979's *Shakedown Street*, featuring images of debauchery and hedonism with police shaking down suspects, winos, stray dogs, hippies dancing in the streets, streetwalking prostitutes, motorcyclists on choppers and longhairs cruising the strip. In time, the parking lot scene at Grateful Dead shows, with its peddlers, vendors and partiers, came to be known as Shakedown Street. While never achieving the total chaos of the cover, had the U.S. Open become the "heart of town"? In addition to the poster, U.S. Open sponsor tents took a whole new look and layout to embrace a festival atmosphere, where people were "encouraged partaking in the scene with cultural food, interactive games and worldly-branded tchotchkes."[1] There were "tie dyes and drug rugs and...psychedelic mushroom parties ironic or otherwise."[2] While only a marketing shtick, it was almost as if Burton endorsed behavior that sometimes resembled the parking lot of Grateful Dead concert.

The Grateful Dead and Burton Snowboards often merged over the years. While Jake was student in Colorado, it was a fateful journey to a Grateful Dead concert that directed his path. Jake had many push-pull factors that guided his ascendency in the sport. On the way to a concert, he broke his collarbone, an injury that led him away from skiing and ultimately away from Colorado. While the mantra is "There Is Nothing Like a Grateful

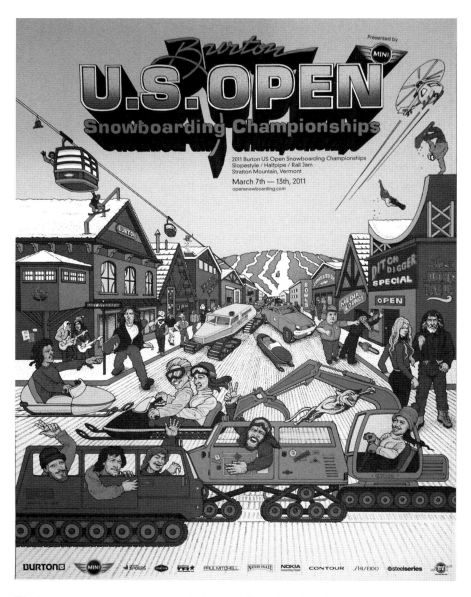

The 2011 U.S. Open Poster reflected a long official and unofficial relationship between Jake Carpenter and the Grateful Dead. *Burton Corporation.*

Dead Concert," for Jake, there was a lifetime of innovation and success that came in lieu of a Shakedown opener.

Like the Grateful Dead, Carpenter rose to success through grass-roots/word-of-mouth promotion and an early anti-establishment vibe. Carpenter also inherited a league of rabble-rousing devotees. In time, a Grateful Dead concert unfortunately became more about the parking lot and less about the music. Similarly, the focus of the U.S. Open was less about competition and more on the buzz. Burton also fell prey to stereotyping writers who held an entire culture accountable to a troublemaking minority. For years, the media focused on the idiosyncrasies of the subculture, such as fashion choices, nomenclature and social behavior, rather than the essence, whether it is collective improvisation or the progression of a sport. Whenever the Grateful Dead arrived in a town, the local media immediately focused on the fans. Rarely was there mention that a band was continually pushing music into new directions night after night, year after year, decade after decade. The early snowboarding media reports were invariably about fashion choices, skateboard lingo and rebellious attitude rather than the sheer pleasure of carving on snow or the ability of twisting in the air.

While performers ranging from the Misfits to L7 to Method Man were the music choice for the U.S. Open entertainment, the Grateful Dead still permeated. When asked about Deadheads and snowboarding, Mike Chantry responded, "There was there was a good crew, there were 'Granola grabbers.' They were always there."[3] Throughout the 1970s and the 1980s, the Grateful Dead were an afterthought to the music industry. To many, they were relics from the psychedelic 1960s. This did not stop a small legion of fans from following the band from town to town. This all changed in 1987, with the group's first Top Ten hit, "Touch of Grey." During the summer of 1987, the Grateful Dead scene went through a profound change. The parking lots overflowed with ticketless fans, and the word was out—there was an incredible experience available to everyone. In the same vein, the 1998 and 2002 Olympics had a similar impact on the U.S. Open. In that four-year span, the U.S. Open transformed from the manageable to the chaotic. As the Grateful Dead was to be forever relegated to large arena shows and the parking lots were filled with the outliers giving the scene a bad name, the U.S. Open also faced infrastructure and crowd control problems.

The Grateful Dead had two performance identities. Out west, they played a much looser concert. When playing on the East Coast, they played with more intensity. Snowboarding followed a similar pattern. "You had the East Coast scene, and you had the West Coast scene," Mike Chantry

remarked. "The West Coast was…kind of more laid back, and the East Coast was kind of like more gritty, grainy" As for the intensity level, "If you compare to zero to ten," Chantry added, "you'd say that was about a six on the West and about a nine on the East."[4]

In 2013, the Grateful Dead and Burton snowboards announced the New Easy Livin' Board Series. The board graphics featured iconic Grateful Dead images such as Steal Your Face, Skull and Roses and Dancing Terrapins. David Lemieux, the Grateful Dead archivist, said that Burton and the Grateful Dead were "kindred spirits."[5] This apparently was an idea long coming. Paul Johnston recalled that "the Grateful Dead was playing on a Sunday night in Albany" immediately after the U.S. Open, so after they "handed out all the [prize] money, we ran down the stairs and jumped in a limo and went to the Grateful Dead concert because Jerry Garcia wanted a snowboard line from Burton with the Grateful Dead on it."[6] The official Burton Snowboards press release said that both the Grateful Dead and Burton "have great legacies built on creativity, community, art and good vibes."[7]

WILL THE CIRCLE BE UNBROKEN?

In March 2013, Mike and Steve Hayes organized the first Vermont Open at Stratton. It was designed for snowboarders of all ages and experience levels. A year earlier, the Hayes brothers planted the seeds for the Vermont Open with the Washed Up Cup, which featured boarders who "went old school wearing hard boots and maneuvering around gates hitting a kicker at the end."[8] Louis Vito felt that after witnessing the participants, "It's hard not to be star struck because no matter how good of a snowboarder you are, those guys made the sport what it was. You'll never trump that no matter how well you do in snowboarding."[9]

After the departure of the U.S. Open, the Friday night event morphed into a full-blown weekend competition. There were four entry categories—junior, amateur, pro and washed up—with three events: a rail jam, a half-pipe and a banked slalom. Steve Hayes remarked, "We wanted to bring back a truly open competition where riders of all ages and from all categories, amateurs, juniors, pro and washed up, could compete together in one arena."[10]

Steve Hayes put together an advisory board, "throwing out ideas" such as "a retro contest, a Snurfer challenge, downhill" with a goal of repeating the

vibe from the 1980s. According to Hayes, "Before the onset of superpipes, pro riders competed in quarter pipes where the emphasis was not just on tricks, but on style."[11] Ryan Foley felt that the sport had advanced too far with the technical moves and twenty-foot pipes. With television exposure, there was "demand seeing those 'holy shit' moments like 'Look what that guy just did.' That's what attracts the viewership but at the same time you're putting people's lives in jeopardy."[12] Veterans of the industry competed in the inaugural event, with several riders using original gear from their heyday. Todd Kohlman recalled the event "was about as close as you get to the early days. Everyone was hooting and hollering and just cheering people on—it was a cool feeling to be a part of that."[13]

The Washed Up Cup, now residing in the Green Door Pub, was the foundation for the Vermont Open. *Brian Knight.*

The actual Washed Up Cup resides at the Green Door Pub. Pete Christy believed that the U.S. Open "may have left, but the heart and soul of snowboarding lives on."[14] For so many of the boarders who passed through the Stratton scene, a common theme was the camaraderie. They made up a small group, often perceived as outcasts, but at the same time, they were progressing the sport at an incredible rate. With the Vermont Open, this camaraderie and progression continues. "I always look at going down to Stratton for the Vermont Open or the Washed Up Cup as a reunion, in a sense." Seth Neary continued, "I didn't go to my high school reunion, and I would go to the Vermont Open."

SINCE THE END IS NEVER TOLD

With the Vermont Open entering its fifth year, a new snowboarding tradition has a foothold in southwest Vermont. The Vermont Open will never replicate the U.S. Open, nor will the U.S. Open ever regain its

intimate beginnings. You can never repeat history, so the best that can be done is honor the sport's tradition and preserve its legacy. This is being accomplished in many different ways. The Vermont Open is a venue for a new generation, including little Hayes and Powers children among the entrants. Ross Powers, Scott Johnston and the Stratton Mountain School Snowboard program continue to develop the next generation, while Ron Chiodi, Dave Redden and Raschid Joyce are all passing the torch to younger riders. Ross Powers and Ryan Foley sit on the USASA board, raising money for rising competitors. Riders like Danny Davis have moved away from technical-driven moves of today's half-pipe competitions and added old-school style and flare. Brew Moscarello resurrected the Snurfer brand, and Jesse Loomis returned to the roots with Powderjet Boards. Ross Powers, Paul Graves, Betsy Shaw, Jake and Donna Carpenter, Paul Johnston, Jeff Brushie and the VTSP Crew have all been inducted into the Vermont Ski and Snowboard Hall of Fame. Many declare the '93–'94 season as the apex of snowboarding and "the last great season before the shit hit the fan" and "a time when the party came first and the contest came second."[15] Photographers like Trevor Graves and Hubert Schriebl have made their decades of documentation available to the public. Facebook features groups such as Vintage Snowboard Trader, Dig My Quiver and the History of Snowboarder that make Throwback Thursdays a 24/7 event. In Burlington, Todd "T.K." Kohlman leads daily tours of a museum in Burton's new research and development facility, Craig's, honoring fallen boarder Craig Kelly. In Londonderry, sculptor Jason Dreweck is working with a dedicated group of volunteers to build a monument to Carpenter and Burton snowboards. Together, these efforts simultaneously preserve and promote the sport. Change may be inevitable, but how we choose to honor the past and look to future is well placed in our hands.

NOTES

Chapter 1

1. Myles Mahoney, interview with the author, August 2017.
2. Ewan Morrison, "Jake Burton Carpenter Interview," *Transworld Snowboarding*, February 9, 2000.
3. Colin Wiseman, "Nobody Said It Would Be Easy," *Frequency, the Snowboarder's Journal* (2013).
4. Ibid.
5. Jean H. Lee, "Snowboarding Is Hot," *Cincinnati Inquirer*, April 14, 2002.
6. Ibid.
7. Portland Helmich, "Chairman of the Board," *Business People Vermont*, August 2000.
8. Ibid.
9. Burton Snowboards Exhibit, 2012 U.S. Open, Stratton, Vermont.
10. Mahoney, interview.
11. Wiseman, "Nobody Said It Would Be Easy."
12. Susanna Howe, *"Sick": A Cultural History of Snowboarding* (St. Martin's Press: New York, 1998), 12.
13. Ian Martin, interview with the author, July 2017.
14. Jack Coghlan, interview with the author, July 2017.
15. Mark Heingartner, interview with the author, July 2017.
16. Morrison, "Jake Burton Carpenter."
17. Wiseman, "Nobody Said It Would Be Easy."

18. Helmich, "Chairman of the Board."

19. Dan D'Ambrosio, "Burton Rides Trends from Vermont to China," *Burlington Free Press*, June 20, 2014.

20. *Going Huge at the U.S. Open, Powder and Rails*, VICE/Burton Snowboards, April 5, 2012, video, https://www.vice.com/en_us/topic/powder-andrails.

21. DK Young, *The History of Stratton, Vermont, to the End of the Twentieth Century* (Stratton, VT: Town of Stratton, 2001), 52.

22. Edie Thys, "Stratton Style," *Ski Magazine*, January 2010.

23. Ibid.

24. Kimet Hand, "Stratton Is Wunderbar!!" *Stratton Magazine*, January 2, 2011.

25. Ibid.

26. Barbara Little, "Tyrolean Days and Chicken Dance Nights," *Stratton Magazine*, November 2011.

27. Ibid

28. "Snow Surfing Tourney Is Sno Joke," Knight News Service, February 6, 1982, newspaper clipping, Muskegon Area Sports Hall of Fame, www.mashf.com.

29. Ski Guru blog, "U.S. Open Special @ Stratton, VT," boston.com, March 18, 2008.

30. Lee, "Snowboarding Is Hot."

31. Heingartner, interview.

32. Wiseman, "Nobody Said It Would Be Easy."

33. Coghlan, interview.

34. Ibid.

35. Ibid.

36. Heingartner, interview.

37. Coghlan, interview.

38. Gilbert Debus, interview with the author, July 2017.

39. Ibid.

40. *U.S. Open Snowboarding Turns "Dirty 30", Powder & Rails*, VICE/Burton Snowboards, 2012, video, March 27, 2015, https://www.vice.com/en_us/topic/powder-and-rails.

41. Ibid.

42. Coghlan, interview.

43. Heingartner, interview.

44. "World's Most Expensive Snowboard," *Snowmagazine*, September 2014.

45. Martin, interview.

46. Coghlan, interview.

47. Debus, interview.

48. John McGrath, interview with the author, June 2017.

49. Coghlan, interview.

50. Heingartner, interview.

51. D'Ambrosio, "Burton Rides Trends."

52. Heingartner, interview.

53. Scott Palmer, interview with the author, June 8, 2017.

54. Ibid.

55. Brew Moscarello, interview with the author, August 2017.

56. Scott Richmond, interview with the author, September 2017.

57. Coghlan, interview.

58. Ibid.

59. Ibid.

60. Wiseman, "Nobody Said It Would Be Easy."

61. Coghlan, interview.

62. Palmer, interview.

63. Ibid.

64. Coghlan, interview.

65. Ibid.

66. Ibid.

67. Ibid.

68. Moscarello, interview.

Chapter 2

1. Heingartner, interview.

2. Ibid.

3. Ibid.

4. Ibid.

5. Ibid.

6. Burton Carpenter, "Snowboarding, The Essence Is Fun," in *To the Extreme: Alternative Sports, Inside and Out*, edited by Robert E. Rinehart and Cynthia Sydnor (New York: SUNY Press, 2012).

7. Wiseman, "Nobody Said It Would Be Easy."

8. Brandon Canevari, "Big 5-0 Arrives for Stratton," *Manchester Journal*, December 14, 2011.

9. Paul Johnston, interview with the author, June 2017.

10. Dave Boettger, interview with the author, June 2017.

11. Ibid.

12. Ibid.

13. Ibid.

14. Neville Burt, interview with the author, July 2017.

15. Ibid.

16. Matt Higgins, "Lawsuits Challenge Ski Resort Liability," ESPN Action Sports, October 13, 2010, espn.com.

17. Andrew Beerworth, "Putting Risk Back on the Downhill Edge: The Case for Meaningful Limitations on Ski Area Liability," in *Worldy Insight and Local Know How* (Burlington, VT: Paul, Frank and Collins, 2015).

18. P. Johnston, interview.

19. Jason Goldsmith, interview with the author, July 2017.

20. Heingartner, interview.

21. P. Johnston, interview.

22. Tricia Byrnes, interview with the author, June 2017.

23. Ibid.

24. Beth Trombly Renola, interview with the author, August 2017.

25. Matt Mitchell, interview with the author, July 2017.

26. Boettger, interview.

27. Richmond, interview.

28. John Edward Young, "Snowboarding. A Growing Sport that's a Cross between Surfing and Skiing Is the Hottest Thing on the Slopes," *Christian Science Monitor*, March 24, 1987.

29. Mitchell, interview.

30. Coghlan, interview.

31. Ibid.

32. Heingartner, interview.

33. Mitchell, interview.

34. Mike Hayes, interview with the author, June 2017.

35. Ibid.

36. Ibid.

37. Ibid.

38. Norman Dalager, "In Charge of the Board," *Boston Globe*, December 2006.

39. Steve Hayes, interview with the author, July 2017.

40. Iseult Devlin, "Burton Celebrates 30 Years at Stratton," *Transworld Business Magazine*, March 15, 2012.

41. Laurie Asperas, interview with the author, August 2017.

42. Pete McCostis, interview with the author, August 2017.

Chapter 3

1. Mitchell, interview.
2. Ibid.
3. Ibid.
4. Ibid.
5. Ibid.
6. Byrnes, interview.
7. P. Johnston, interview.
8. Neville Burt, interview with the author, June 2017.
9. Ibid.
10. Ibid.
11. Moscarello, interview.
12. Mitchell, interview.
13. P. Johnston, interview.
14. Burt, interview.
15. Seth Neary, interview with the author, July 2017.
16. Burt, interview.
17. Ibid.
18. Byrnes, interview.
19. P. Johnston, interview.
20. Neil Korn, interview with the author, July 2017.
21. Alexie Garick, interview with the author, August 2017.
22. Alvah Wendell, interview with the author, September 2017.
23. Neary, interview.
24. Trombly Renola, interview.
25. Lauren Traub Teton, "Going to Snowboard Camp with Tricia Byrnes," snowboardsecrets.com, April 13, 2015.
26. Ibid.
27. Tommy Hine, "Byrnes Turning Up Everywhere," *Hartford Courant*, February 19, 2000.
28. Neary, interview.
29. Trombly Renola, interview.
30. Alex Tresniowski, "High Flyer," *People*, February 18, 2002.
31. Hine, "Byrnes Turning Up Everywhere."
32. Thebault, interview.
33. Mitchell, interview.
34. Seth Miller, interview with the author, July 2017.
35. Neary, interview.

36. Scott Johnston, interview with the author, July 2017.
37. Ross Powers, interview with the author, July 2017.
38. Ibid.
39. Ian Price, interview with the author, September 2017.
40. Wiseman, "Nobody Said It Would Be Easy."
41. Ibid.
42. Dana White, "Jake and the Rad Man," *Skiing Magazine*, December 1989.
43. Wiseman, "Nobody Said It Would Be Easy."
44. Bill Reed, "Snowboarding: The Endless Winter," *Skiing Magazine*, January 1986.
45. M. Hayes, interview.
46. Heingartner, interview.
47. Ibid.
48. Powers, interview.
49. Heingartner, interview.
50. Ibid.
51. Jason Ford, interview with the author, August 2017.

Chapter 4

1. Ibid.
2. Price, interview.
3. John Thouborron, interview with the author, September 2017.
4. Ibid.
5. Shem Roose, interview with the author, September 2017.
6. Thouborron, interview.
7. USASA website, www.usasa.org.
8. James Tabor, "Doctor Shred," *Ski Magazine*, January 1990.
9. David Alden, *Snowboarder Magazine*, Evolution issue, October 1995.
10. Jason Goldsmith, interview with the author, June 2017.
11. Rob Seidenberg, "Shreddin' USA," *Ski Magazine*, 1989.
12. Ibid.
13. Palmer, interview.
14. Ibid.
15. "Snobored? It's Your Year to Snowboard," *Ski Magazine*, December 1988.
16. Ibid.
17. Betsy Shaw, interview with the author, July 2017.
18. Ibid.

19. Shaw, interview.
20. Price, interview.
21. Ibid.
22. Dana White, "Shredheads Go Mainstream," *Skiing Magazine,* September 1988.
23. P. Johnston, interview.
24. Ibid.
25. Thebault, interview.
26. P. Johnston, interview.
27. Ford, interview.
28. Miller, interview.
29. P. Johnston, interview.
30. Trevor Graves, interview with the author, June 2017.
31. Ryan Foley, interview with the author, September 2017.
32. Price, interview.
33. Graves, interview.
34. Miller, interview.
35. Goldsmith, interview.
36. Neary, interview.
37. Ford, interview.
38. Neary, interview.
39. Powers, interview.
40. Dave "Hooter" Van Houten, interview with the author, July 2017.
41. Ibid.
42. Neary, interview.
43. Goldsmith, interview.
44. Garick, interview.
45. Kris Swierz, interview with the author, July 2017.
46. Powers, interview.
47. Neary, interview.
48. Ibid.
49. Goldsmith, interview.
50. Ford, interview.
51. Roose, interview.
52. Price, interview.
53. Ibid.
54. Ibid.
55. Ford, interview.
56. Moscarello, interview.

57. Neary, interview.
58. Foley, interview.

Chapter 5

1. Wiseman, "Nobody Said It Would Be Easy."
2. Ibid.
3. D'Ambrosio, "Burton Rides Trends."
4. Chris Copley, interview with the author, July 2017.
5. P. Johnston, interview.
6. Jon Yousko, interview with the author, August 2017.
7. David Schmidt, interview with the author, August 2017.
8. Ibid.
9. Moscarello, interview.
10. Ibid.
11. Ibid.
12. Ibid.
13. Copley, interview.
14. Ibid.
15. Yousko, interview.
16. Ibid.
17. Ibid.
18. Ibid.
19. Wiseman, "Nobody Said It Would Be Easy."
20. Schmidt, interview.
21. Carol Plante, interview with the author, August 2017.
22. Schmidt, interview.
23. Ibid.
24. Copley, interview.
25. Ibid.
26. Plante, interview.
27. Ibid.
28. Ibid.
29. Moscarello, interview.
30. Thouborron, interview.
31. Richmond, interview.
32. Thouborron, interview.
33. Richmond, interview.

34. Ford, interview.
35. Ibid.
36. Thouborron, interview.
37. Richmond, interview.
38. Schmidt, interview.
39. Jennifer Sherowski, "Faces: John 'JG' Gerndt," *TransWorld SNOWboarding,* September 6, 2007.
40. Ibid.
41. Richmond, interview.
42. "Snowboard Designer & Engineer—Paul Maravetz," malakye.com, December 1, 2014.
43. Todd Davidson, interview with the author, June 2017.
44. M. Hayes, interview.
45. S. Hayes, interview.
46. Moscarello, interview.
47. Davidson, interview.
48. Moscarello, interview.
49. Thouborron, interview.
50. Ibid.
51. Ibid.
52. Richmond, interview.
53. Ibid.
54. Davidson, interview.
55. Ibid.
56. Richmond, interview.
57. Yousko, interview.
58. Copley, interview.
59. Thouborron, interview.
60. Emmett Manning, interview with the author, August 2017.
61. Yousko, interview.
62. Plante, interview.
63. Richmond, interview.
64. Ibid.
65. Ibid.
66. Korn, interview.
67. Goldsmith, interview.
68. Foley, interview.
69. Powers, interview.
70. Ibid.

71. Jesse Loomis, interview with the author, July 2017.

72. Manning, interview.

73. Ibid.

74. Ibid.

75. Roose, interview.

76. Manning, interview.

77. Scott Lenhardt, interview with the author, August 2017.

78. Ibid.

79. Roose, interview.

80. Loomis, interview.

81. Moscarello, interview.

82. Lenhardt, interview.

83. Loomis, interview.

84. Roose, interview.

85. Manning, interview.

86. Roose, interview.

87. "Randy Gaetano," *TransWorld SNOWboarding*, August 29, 1997.

88. Moscarello, interview.

89. Dan D'Ambrosio, "Manchester Company Bringing Snurfer Back to the Slopes," *Burlington Free Press*, November 27, 2014.

90. Moscarello, interview.

91. Ibid.

92. Lenhardt, interview.

93. Moscarello, interview.

94. Chip Allen, "Hayes Brothers Snowboards Returns to Vermont," *TransWorld SNOWboarding*, April 2011.

95. M. Hayes, interview.

96. "PowderJet Snowboards with Jesse Loomis," *Snowboard Steez*, podcast, September 4, 2013.

97. "PowderJet Snowboards Part I," *N'East Magazine*, April 4, 2013.

98. "Libble-D," *10 Engines*, March 16, 2010.

99. Rich Titus, interview with the author, August 2017.

100. Shaw, interview.

101. Copley, interview.

102. Thouborron, interview.

103. Manning, interview.

104. Plante, interview.

105. M. Hayes, interview.

106. Graves, interview.

107. Manning, interview.
108. Schmidt, interview.
109. Plante, interview.

Chapter 6

1. Powers, interview.
2. Ibid.
3. Lenhardt, interview.
4. Copley, interview.
5. Hobie Chittenden, interview with the author, July 2017.
6. S. Hayes, interview.
7. Price, interview.
8. Powers, interview.
9. Neil Korn, "Hobie Chittenden," *Eastern Edge Magazine*, 2000.
10. Chittenden, interview.
11. Powers, interview.
12. Copley, interview.
13. Graves, interview.
14. Byrnes, interview.
15. Ibid.
16. Chris Karol, "Riding the Beast: Has Snowboarding Lost Its Soul?," *Medium*, September 2014.
17. Price, interview.
18. M. Hayes, interview.
19. Palmer, interview.
20. Thouborron, interview.
21. Peter Bauer, interview with the author, 2017.
22. Ibid.
23. Copley, interview.
24. Swierz, interview.
25. Vermont Ski and Snowboard Museum and Vermont Ski and Snowboard Hall of Fame, www.vtssm.org.
26. Goldsmith, interview.

Chapter 7

1. Heingartner, interview.
2. Graves, interview.
3. Palmer, interview.
4. Ross Rebagliati, *Off the Chain: An Insider's History of Snowboarding* (Toronto: Greystone Books, 2009).
5. Ibid.
6. "Going Huge at the U.S. Open."
7. Palmer, interview.
8. Graves, interview.
9. Palmer, interview.
10. Ibid.
11. "Freinademetz Arrested after Brawl at Stratton," *TransWorld SNOWboarding*, March 21, 2000.
12. Ibid.
13. Neary, interview.
14. Loomis, interview.
15. Zander Livingston, interview with the author, September 2017.
16. P. Johnston, interview.
17. Price, interview.
18. Ibid.
19. Copley, interview.
20. John Conway, "What Went on at the 1999 U.S. Open," *Vermont Review*, March 24–April 13, 1999.
21. Tessa McCullough, "Underage Debauchery: Yobeat at the U.S. Open," *Yobeat Magazine*, 2005.
22. Colin Whyte, "The U.S. Open Turns Dirty Thirty," *X Games Online*, March 6, 2012.
23. Brooke Geery, "Old Gold—The U.S. Opening Drinking Game," brookegeery.com, March 2006.
24. Korn, interview.
25. Miller, interview.
26. Mitchell, interview.
27. Swierz, interview.
28. Mitchell, interview.
29. Miller, interview.
30. Ibid.
31. Neary, interview.

32. Swierz, interview.

33. Korn, interview.

34. Neary, interview.

35. Todd Davidson, interview with the author, June 2017.

36. Foley, interview.

37. S. Johnston, interview.

38. Miller, interview.

39. Ford, interview.

40. S. Hayes, interview.

41. Ibid.

42. M. Hayes, interview.

43. Byrnes, interview.

44. Trombly Renola, interview.

45. Lenhardt, interview.

46. Palmer, interview.

47. Korn, interview.

48. Ibid.

49. S. Hayes, interview.

50. Ibid.

51. Ibid.

52. Price, interview.

53. Swierz, interview.

54. Ford, interview.

55. Ibid.

56. Roose, interview.

57. Shaw, interview.

58. Goldsmith, interview.

59. Moscarello, interview.

60. Powers, interview.

61. Foley, interview.

62. S. Hayes, interview.

63. Palmer, interview.

64. S. Hayes, interview.

65. Byrnes, interview.

66. Swier, interview.

67. Moscarello, interview.

68. Titus, interview.

69. Ibid.

70. Tom Monterossom, "Open Minded," *Snowboarder Magazine*, March 13, 2013.

71. Neary, interview.
72. Powers, interview.
73. Miller, interview.
74. Price, interview.
75. Byrnes, interview.
76. Miller, interview.
77. Price, interview.
78. Dennis Healy, interview with the author, August 2017.
79. Neary, interview.
80. Goldsmith, interview.
81. Powers, interview.
82. Lenhardt, interview.
83. Ibid.
84. Keith Hannum, interview with the author, August 2017.
85. Titus, interview.
86. Ibid.
87. *U.S. Open Snowboarding Turns "Dirty 30"*.
88. Ibid.
89. Pete Christy, interview with the author, May 2017.
90. Neary, interview.
91. "Winhall's Red Fox Inn Turns 50 This Year," *Bennington Banner*, October 3, 2010.
92. Pete Biolsi, "The Red Fox Inn: Vermont's Best Irish Pub," undiscovered.com, October 27, 2011.
93. "39th Annual Bondville St. Patrick's Day Parade, Sunday, March 17, 2013," www.redfoxinn.com, 2013.
94. Ibid.
95. Seth Beck, "The Mark Sullivan Interview pt1," *Seven Years Winter*, January 4, 2013.
96. "Going Huge at the U.S. Open."
97. Miller, interview.
98. Ford, interview.
99. Beck, "Mark Sullivan Interview."
100. "Going Huge at the U.S. Open."
101. Beck, "Mark Sullivan Interview."
102. Dennis Healy, interview with the author, June 2017.
103. Ibid.

Chapter 8

1. Titus, interview.
2. Letter, Stratton Corporation, March 26, 1996.
3. Ibid.
4. Ibid.
5. Interview with Keith Hannum, August 2017.
6. Foley, interview.
7. Diane Pucin, "Control at Olympics Causing Controversy Snowboarding Goes Legit—But Unhappily," *Philadelphia Inquirer*, January 25, 1998.
8. Powers, interview.
9. Ibid.
10. Vanessa Beattie, "Manchester Native Inducted into Hall of Fame," *Manchester Journal*, October 2014.
11. Shaw, interview.
12. Powers, interview.
13. Paul J. MacArthur, "The Top Ten Important Moments in Snowboarding History," smithsonian.com, February 5, 2010.
14. Christy, interview.
15. Titus, interview.
16. Healy, interview.
17. Ibid.
18. "U.S. Open Part 2: Black and Night Rail Jam and Amp Energy Party," *Snowboard Magazine*, March 2010.
19. Ibid.
20. Powers, interview.
21. Ibid.
22. Price, interview.
23. Palmer, interview.
24. Copley, interview.
25. Gerhard Gross, "Burton U.S. Open Moves to Vail, Colorado for 2013," *TransWorld SNOWboarding*, July 2012.
26. Ibid.
27. Colin Whyte, "Tastemaker: Pat Bridges," *ESPN X Games Online*, December 2012.
28. Wiseman, "Nobody Said It Would Be Easy."

Epilogue

1. "Come See What's New at the 29th Annual Burton U.S. Open," Burton Snowboards press release, March 3, 2011.
2. Tom Monterosso, "U.S. Open 2011...Peace Out," *Feel the Byrnes*, blog, March 15, 2011.
3. Mike Chantry, interview with the author, June 2017.
4. Ibid.
5. "Burton Snowboards in Collaboration with the Grateful Dead Presents the New Easy Livin' Board Series for Winter 13," Burton Snowboards press release, October 7, 2012.
6. P. Johnston, interview.
7. "Burton Snowboards in Collaboration."
8. Devlin, "Burton Celebrates 30 Years at Stratton."
9. Ariston Anderson, "Thirty Years Later, Burton U.S. Open Preserves Its Roots," *HuffPost*, March 15, 2012.
10. Meryl Robinson, "It's in Their Genes," *Stratton Magazine*, November 21, 2013.
11. Max Boxler, "A New Tradition: Hayes Brothers Ramp Up Vermont Open at Stratton," *New England Ski Journal*, Spring 2013.
12. Foley, interview.
13. Devlin, "Burton Celebrates 30 Years at Stratton."
14. "Stratton Holds First Vermont Open," *Brattleboro Reformer*, March 9, 2013.
15. www.93-94.com.

INDEX

INDEX

ABOUT THE AUTHOR

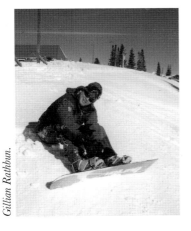

Brian Knight is a self-employed historic preservation consultant and architectural historian. He works throughout Vermont preserving the state's cultural resources and built environment. His first book, *No Braver Deeds*, chronicled the Equinox Guards, Company E, Fifth Vermont, in the Civil War. While working for Stratton in the 1980s and early 1990s, writing for a local magazine in the late 1990s and then teaching history at the Stratton Mountain School, he has been an objective observer of snowboarding in southwest Vermont. He presently lives in Dorset, Vermont.

DATE DUE

BRODART, CO.

Cat. No. 23-221